The Illustrated Guide to Film Scanning

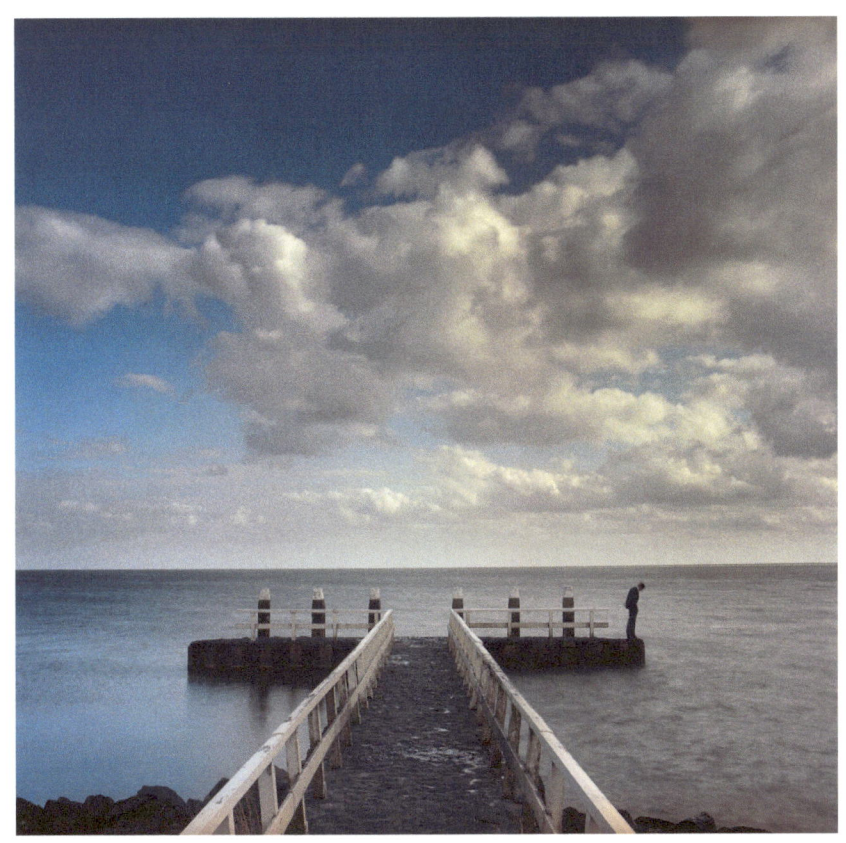

A best-practice guide to scanning
negatives and transparencies

Gerard Kingma

For my patient wife and my loving sons

All text and images © Gerard Kingma

Edited by Ragini Werner | *NEEDSer* **www.needser.nl**

No reproduction without written authorization from the author. All rights reserved

First edition 2013

For enquiries, please contact the author at **www.kingma.nu**

Introduction

Obtaining a high-quality scan from consumer-grade scanners such as the Nikon Super Coolscan LS9000 or the Epson V750 flatbed scanner can be a frustrating experience. Some manuals are not very instructive, software interfaces are often obtuse, and scanner manufacturers sometimes make claims that are less than helpful.

Moreover, many scanning workflows involve deciding what the image should look like, or how large it should be displayed. Such decisions should not be made during the scanning process, but in a far later stage.

The workflows I describe here aim to extract objectively the maximum amount of detail that is present in the original medium, in the highlights as well as in shadow areas, without imposing a subjective interpretation onto the look of the image, on screen or in print.

Many tutorials proceed along these lines: decide how large to print your image, how much contrast and saturation you find pleasing, how to sharpen it, and then scan your image. But more often than not, I find that I cannot answer these questions when I am scanning an image. Or I find that I must answer them differently at a later stage. As a result, I must go back and re-scan the image, if I decide later on that I want to print a larger version of the image, or that I find the scan too contrasty.

I decided that my goal was to scan an image just once, to obtain some sort of digital negative, a source that would contain all relevant detail that would always let me make prints of any size, or so that I could change the look of the image in terms of saturation and contrast without having to go through the laborious rigmarole of re-scanning.

Broadly speaking, then, in the scanning software or the scanner driver, I switch off all functions that involve decisions about contrast and saturation, about the look of the image. I obtain from the scanner an unprocessed image at maximum bit depth and optical resolution, a kind of RAW file if you will.

This method requires first and foremost an adequate scanner. I use a Nikon Super Coolscan LS9000 for 35 mm film and medium format film, and an Epson V750 Pro for 4x5" large format sheet film and for making contact scans from medium format negative films. An Imacon Flextight or drum scanner arguably produces better results, but at a much higher cost. I find the quality produced by the LS9000 to be adequate, but it does not accept 4x5" film; for that I use the Epson, which produces scans that I find too soft for 35 mm and medium format, but which is just adequate for large format. However, the workflows described here are applicable to many available flatbed or dedicated film scanners.

As to software, in these workflows I use VueScan (**www.hamrick.com**) or SilverFast Ai 6 (**www.silverfast.com**) to scan the image, and Adobe Photoshop CS5 (**www.adobe.com**) with the ColorPerfect plug-in (**www.c-f-systems.com/Plug-ins.html**) from CFSystems to process the image. The workflows describe scanning processes for both negative and transparency films.

These workflow descriptions are based on my personal 'best practice' experience, the result of trial and error and many, many hours of scanning. More often than not, I found myself applying settings in the scanner driver or software, Photoshop or ColorPerfect that I did not quite understand, because the relevant function was not described, or not described in a way that I could comprehend. In those instances I applied the most basic of scientific research principles: study the result, change one parameter *and only one*, study the result again and compare the difference. Then choose the best result, and proceed to the next parameter. I do not always provide my reasoning for choosing one particular setting over another in these workflow descriptions. I simply describe what has proven to work best for my specific purpose: extracting as much data as possible without interpreting it.

Positive transparency versus negative film

Positive transparency film used to be my favorite medium. A well-exposed slide is rich in color and texture. When it works, it works really well. I spent many an evening projecting 35 mm slides onto a white wall. That is an almost cinematic experience all of its own, which no paper print can match. Naturally you can connect a beamer to your computer and project your digital files, but most beamers do not match the resolution and color intensity of traditional slides.

Opening the package of developed transparencies from the lab, laying them out on the light table, poring over the images with a loupe to see if I got the focus right — when it works, it is immensely satisfying.

But when you wish to scan these images to make prints, color transparencies have a distinct disadvantage compared to negative film: the exposure range of transparency film, meaning the number of light levels (measured in stops) that a single exposure on film can contain, is much smaller than that of negative film. With transparency film, the exposure range is about 6-7 stops. Most scanners have difficulty extracting dark shadow detail. Brighter slides result in better scans, but over-exposing is not the solution: you have to expose transparency film very carefully, because highlights tend to blow out very easily. No amount of post-processing can bring back information that the film simply does not contain, from either dark, blocked-up shadows or blown-out highlights.

Negative film is far more forgiving in this respect. The exposure range of negative film such as Kodak Portra that I like to use is typically 10-12 stops. Negative film does not like under-exposure; that results in grainy shadows. Yet it is very forgiving of over-exposure. I typically over-expose negative film by at least one stop. This ensures good detail in shadow areas and good color in brighter areas.

But negative film has a distinct disadvantage as well. Because of the orange color mask and the inversion of the primary colors, on the light table it is very difficult to judge whether an image will work or not. Careful selection of the most useful frames of the film requires scanning and post-processing the entire film.

After I have developed a negative film (I develop the films at home with Tetenal Rapid C-41 with the aid of a Jobo CPE2 processor), I make a low-resolution contact scan of the entire film on the Epson V750 flatbed scanner. This allows me to pick out the best frames, which I then scan individually.

Color management

Proper color management is essential. It starts with a calibrated monitor, but your scanner should also be calibrated. Any imaging device, be it a monitor, a scanner or any combination of printer, ink and paper, does nothing more than collect or display a dataset of numbers. This dataset is not absolute, but relative in nature. It is defined relative to whatever the device is actually capable of.

To describe it crudely: if you scan a color transparency with an image of a red balloon, the scanner will pass the collected data on to the computer as a collection of numbers. If it could talk, it would say for instance: "I'm giving you 82% red." The computer then obviously would ask: "82% of what?" To which the scanner would reply: "82% of what I'm capable of registering." In order for the computer to interpret the color of the balloon correctly (and for the monitor to display it correctly, and for the printer to print it correctly), it must know to which 100% this 82% is related. If you do not know what the 100% is, the 82% has no meaning. That is where calibration, or rather, profiling comes in.

As an aside, profiling and calibrating are not the same thing. When you calibrate a device, you return it to a state in which it operates according to parameters with specified, controlled values. When you profile a device, you describe its behavior under specified circumstances. Some scanners (including the Nikon LS9000) have separate routines for both procedures. The Nikon LS9000 is automatically calibrated when you switch it on; there should be no film holder in the scanner during this procedure, which takes about a minute (wait for the green LED to stop blinking). The profiling procedure scans an IT8 target in order to build an ICC profile.

In order to profile a device, you activate a piece of software that feeds a known, industry-standard dataset to the device, and then measures the output from that device. Based on this result, it calculates the difference between the color values that the device should render and the values it actually renders. The software then builds a profile that describes exactly how the device handles the real-life colors you feed it.

This is called an ICC profile. You can make ICC profiles for any color device: a monitor, scanner or printer/ink/paper combination (in color management, a particular printer with glossy paper is a different device from that same printer with matte paper. Many photo-quality printers use different black inks for matte and glossy surfaces).

To make the concept of ICC profiles visually more comprehensible, you can graphically plot these datasets (collections of numbers) with some nifty software, Gamutvision by Norman Koren (**www.gamutvision.com**). This software can map an ICC profile into a 3D model. The result looks like a balloon, or a cloud, which represents all the colors an imaging device can detect or display. The ICC profile for my Nikon LS9000 scanner is the one on the left, while the ICC profile for my Eizo monitor is the one on the right:

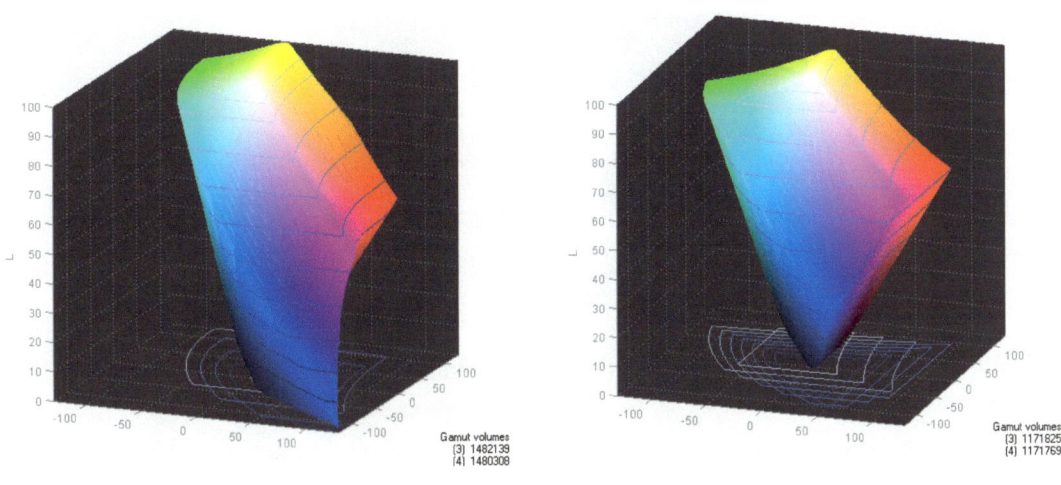

Nikon LS9000　　　　　　　　　　　　　　Eizo CG222W

If the gray cube represents all the colors that can exist in theory, the colored cloud represents the colors that the device can actually detect or display. They are plotted in three dimensions: white at the top and black at the bottom in the vertical dimension, and the primaries red, blue and green in the two horizontal dimensions.

Obviously there are many different brands and models of scanners and monitors and other imaging devices in the world. That is why the industry has specified a number of color clouds, or rather color spaces, that are device independent. In Photoshop, these are called working spaces. If you convert the data that describes your scanner or monitor to an independent working space, a third device such as your inkjet printer or your publishers' offset printer no longer needs to know which scanner you are using. In Photoshop you choose a device-independent color space as your working space. There are a couple of different color spaces; they have names such as sRGB, Adobe RGB (1998) and ProPhoto RGB.

Once you have converted the dataset defined by your scanner profile to your working space, where this information came from is no longer relevant: it is now referenced to an industry standard rather than to your individual scanner. If you convert your image, now tagged with your profile MyScanner.icc to the working space sRGB, it will be correctly interpreted by each and every other computer, because sRGB is an internationally known standard, while MyScanner.icc is not.

All imaging devices behave differently. There are colors that your scanner can detect which your monitor or your printer cannot display. Matte papers, for instance, are not very good at representing deep blacks. The color cloud of device A may be smaller than device B's. If you overlay the color space of my Nikon scanner (the colors the scanner can detect) onto the color space of my Eizo monitor (representing the colors the monitor can display) in Gamutvision, it looks like this:

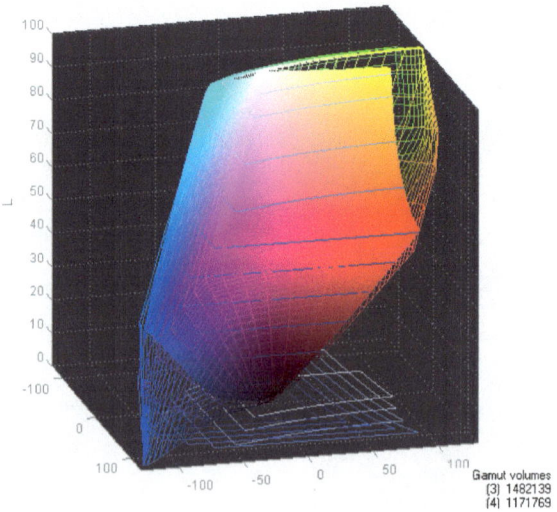

Scanner (wire frame) vs. Monitor (solid cloud)

The wire frame represents the scanner; the solid cloud represents the monitor. It immediately becomes apparent that the scanner can detect colors that the monitor cannot display, most notably deep dark blues and light greens.

Similarly, there are differences in volume in the device-independent working spaces that you can use as your working space in Photoshop. The working space defined as the international standard color space for internet display, sRGB, is smaller than the working space that has become popular in the photography industry, Adobe RGB (1998). Let us compare these in Gamutvision:

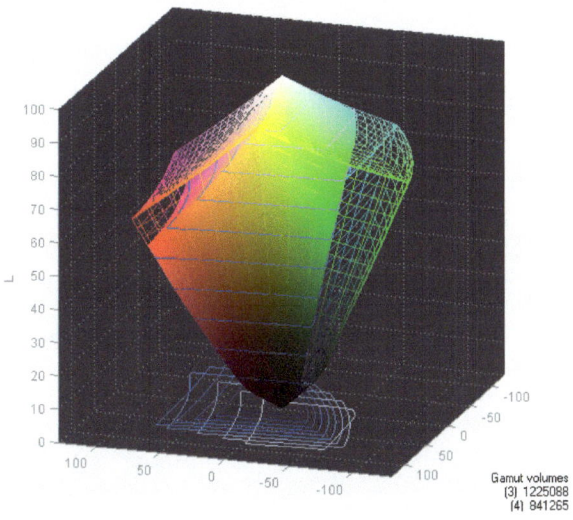

Adobe RGB (1998) (wire frame) vs. sRGB (solid cloud)

The color space Adobe RGB (1998) (wire frame) contains more colors than sRGB (solid cloud).

Now, if you wish to convert your scanner data to a device-independent color space, it would of course make sense to convert the data into the largest available color space. You would be throwing colors away if you converted them to a space too small to contain them. The largest space popular in photography is not Adobe RGB (1998), but ProPhoto RGB. Let us compare these in Gamutvision:

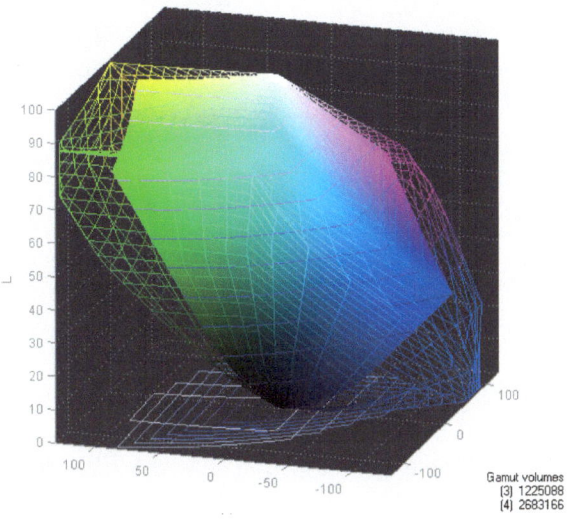

ProPhoto RGB (wire frame) vs. Adobe RGB (1998) (solid cloud)

This is the color space of the Nikon scanner plotted into the independent working space ProPhoto RGB:

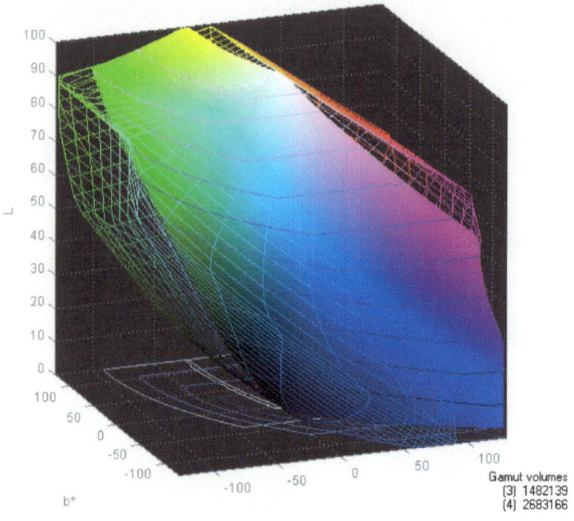

ProPhoto RGB (wire frame) vs. Nikon LS9000 (solid cloud)

Here you can see that the scanner can detect some colors that the working space cannot contain (deep blues), but the working space also allows for colors that the scanner cannot detect (lighter greens). This exercise clearly demonstrates that if you are scanning your films to archive every bit of data that the film contains, it makes sense to use the largest possible color space in Photoshop.

However, in such a large cloud, colors can 'stretch' as it were, which can result in unwanted banding or posterization effects in your images. You can prevent this by chopping up data into smaller units, so that more even gradations can be rendered. To do that, it is advisable to work in 16 bit mode rather than 8 bit mode. This makes the file larger and requires more computer real estate, but it is a must when you are aiming for maximum image quality.

You now have a file that a browser will not understand for display on the internet. For that you must convert the file to 8 bit mode and into the smaller color space sRGB, and then save it as a jpg.

For imaging devices to work together properly, you need an ICC profile that describes your scanner, a profile that describes your monitor, and you need to understand how these interact with your working space in Photoshop. What happens when you convert colors from a larger space into a smaller space? Obviously, some colors (such as deep blues) will have to be changed or discarded, because they will not fit into the smaller space. That is where rendering intent comes into play.

Two basic choices are relevant. You can choose to leave intact the colors that will fit the smaller space anyway, and place the colors that will not fit at the edges of the smaller space. Or, you can compress all colors slightly so that the larger cloud will fit into the smaller cloud. The first method of rendering colors is called Relative colorimetric; the second method is called Perceptual. With Perceptual the result can look more even, but because in real-life photography most colors will fit the target space anyway, I choose Relative colorimetric because I want those colors to change as little as possible. When you choose Relative colorimetric, you should perform the conversion with black point compensation (BPC) switched on.

So, monitor calibration is a must. Scanner calibration is very highly recommended, but if you do not have the means to profile the scanner yourself, but you do have SilverFast scanning software, you can use the ICC profile supplied with SilverFast for your scanner. SilverFast provides generic ICC profiles for many popular scanner models.

However, I recommend you perform an IT8 calibration of your own scanner. This requires a target, which is a color transparency with a number of patches of known color values, and software to measure the scan and to build the profile. You can order such a target from LaserSoft Imaging (the company that produces SilverFast), together with the necessary software; follow the instructions to perform the calibration and to install and apply the profile. I would however recommend obtaining an IT8 calibration target from Wolf Faust at **www.targets.coloraid.de** and performing the calibration with VueScan. Just follow the instructions in VueScan to build and apply the profile.

If you are interested in negative scanning, you may wonder how a positive transparency target might help you. The idea is not to build a profile that describes a particular film, but to describe the behavior of the scanner. At a later stage in the workflow, the Photoshop plug-in ColorPerfect interprets the 'RAW' data the scanner produces. This plug-in interprets the data from the scanner as if it were a snapshot of film on a light table – it does not matter whether it is a color transparency or a negative. It is however very important that this snapshot from the scanner resembles the actual film as closely as possible, and that is why you need an ICC profile which describes the behavior of the scanner.

So, at this point, you have installed Adobe Photoshop (I use CS5), your scanner driver, SilverFast Ai (I use 6.6) or Hamrick's VueScan and the Photoshop plug-in ColorPerfect from CFSystems. You have calibrated your monitor and your scanner. Now you can start scanning your films.

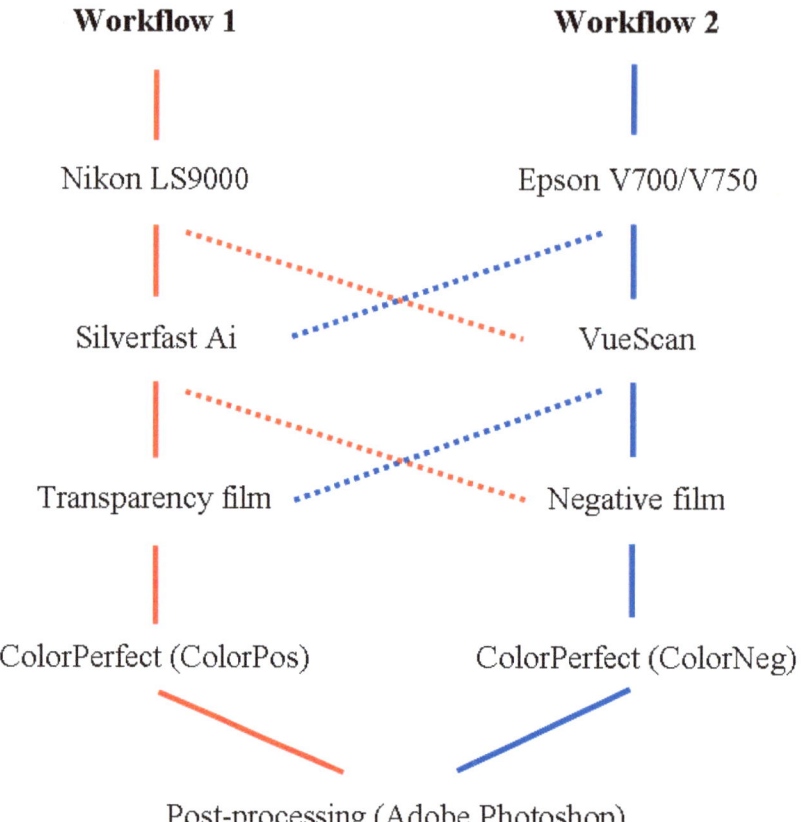

The solid lines in this illustration outline the two workflows that I fully describe in this manual. As the dotted lines indicate, you can of course use either the Nikon LS9000 or the Epson V700/750 scanner for both transparency film and negative films, and you can scan both film types with either SilverFast Ai or VueScan. Negative scans are processed with the ColorNeg module, and transparency films are processed with the ColorPos module. The ColorPerfect plug-in contains both modules. All results are post-processed in Adobe Photoshop.

If you use an Epson to scan negatives, you can of course jump straight to Workflow 2. Similarly, if you use a Nikon to scan your transparencies, you do not need to study Workflow 2. However, the examples are post-processed differently, so you may find it instructive to read both workflow descriptions.

Again, you might want to read both workflows if you follow a route along dotted lines in the illustration above. For instance if you use the Epson with SilverFast to scan transparencies, or the Nikon with VueScan to scan negatives.

The main differences between the two scanners I use are outlined in the table below.

Nikon LS9000	Epson V750
Price: scanner is discontinued and only available used. Check online auction sites, but expect to pay US$ 1500-2500	Around US$ 800. The scanner is in production (2013)
Film size: scans 35 mm and medium format roll film (6x4, 5, 6x6, 6x7 & 6x9)	Scans any media up to 8x10"
Resolution: detailed scans at 4000 dpi	Output scans are more woolly or soft than from the Nikon. Actual, real-world resolution no higher than 3200 dpi. Higher dpi settings (up to 6400 dpi) do not extract more detail
Precise focusing	No focusing other than three configurations of height adjusters
Better color accuracy, especially in the shadow areas	Good color accuracy, but not as good as the Nikon
Effective dust and scratch removal with digital ICE	ICE does not work as well as on the Nikon; can degrade micro detail
SilverFast is not bundled	SilverFast comes bundled with the V750 (not with the V700)

I use two software solutions to scan film: SilverFast Ai 6 and VueScan. SilverFast Ai is bundled with the Epson V750, unlike the Epson V700 (which is internally by and large the same scanner). If you have both SilverFast and VueScan, it is largely a matter of personal preference whether you use SilverFast or VueScan. Both packages have their advantages and disadvantages. If you follow the workflows described here, you will find most functions are unused in both packages, because you will use both to produce uncorrected 'RAW' files. The resulting scans will be very similar.

The main advantage of VueScan over SilverFast is cost. VueScan is much cheaper than SilverFast to begin with and you only have to buy one license, whereas SilverFast requires you to buy separate licenses for each scanner that you own. If you don't have SilverFast Ai 6 already (it comes bundled with the Epson V750), my recommendation for the workflows described here is to stick with VueScan.

The workflows I describe are based on the premise that you take a 'RAW snapshot' of your film, which is subsequently post-processed in ColorPerfect and Photoshop. Both transparencies and negatives are therefore scanned in positive mode, producing uncorrected and unprocessed linear output. Both SilverFast Ai 6 and VueScan have various methods for scanning and converting negative film to a positive image, but I don't use them. The route through ColorPerfect is more laborious, but in my opinion produces better results by a long, long way.

Workflow 1: Scanning positive transparencies on the Nikon LS9000 with SilverFast Ai

1. For this tutorial, I have chosen an image of a wall in blue stucco with giant hogweed. It was shot with a Hasselblad 501CM on Fujichrome Provia 400X.

Load the film in the film holder (I use the glassless holder) and insert the holder into the scanner. Start SilverFast Ai with the stand-alone utility (SilverFast Launcher) or through the **Import** menu in Photoshop.

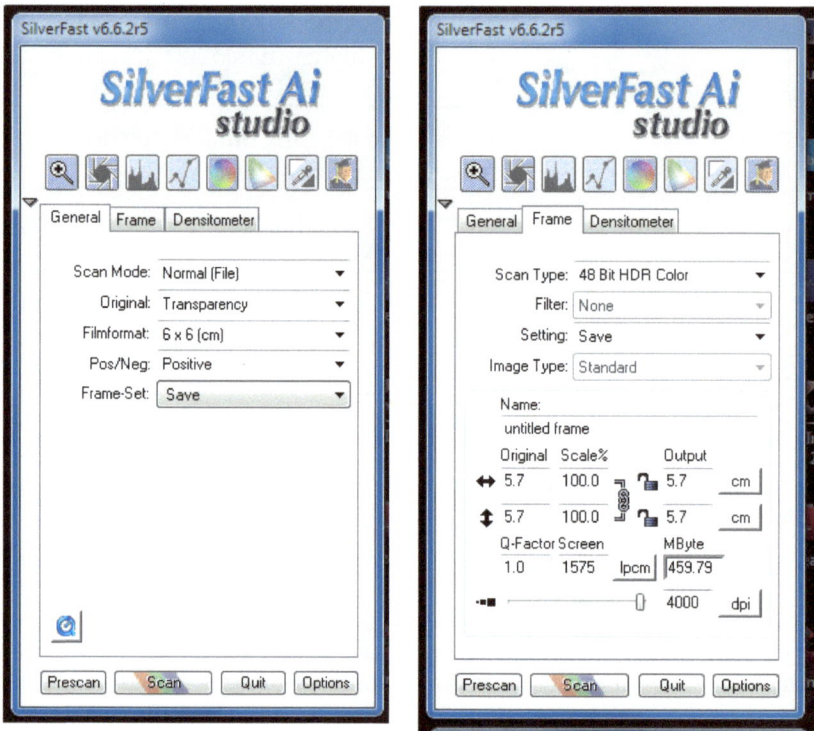

2. Set the options for the tabs **General** and **Frame** as indicated above. On the **Frame** tab, an important setting is **Scan Type: 48 Bit HDR Color.** With this type, the file will not be post-processed in SilverFast. The scan is saved as a linear 16 bit tiff file. No processing is applied at this stage, and the resulting file will look very dark when you first open it in Photoshop. Note that all processing buttons in the top row are grayed out.

Also note that the scan resolution is set to 4000 dpi. This is the maximum optical resolution for this scanner model. It represents the maximum amount of detail that this scanner is capable of extracting.

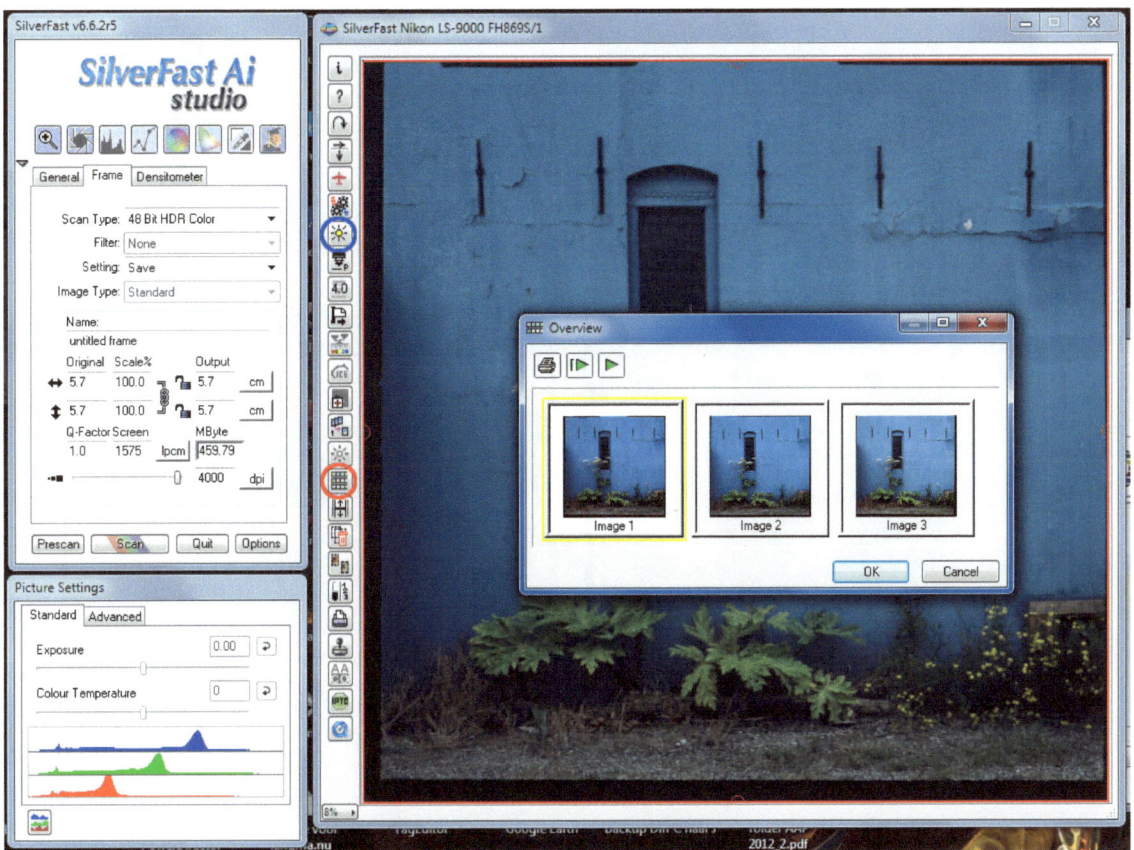

3. Your screen should look something like this. Click on **Set automatic exposure** (blue circle) and then click on **Overview** (red circle). Click on the middle **Pause/Play** button to generate an overview of the images on the film strip. Click on the frame of your choice and click **OK** to make a prescan. If automatic exposure is selected, SilverFast will determine the optimum scanner exposure for the frame.

4. Click **Options** and choose the settings on the **General, Auto, CMS** and **Special** tabs as indicated above. Some of these settings, such as **Units of Measure**, are of course personal preferences.

On the **General** tab, note the tick box on **Gamma Gradation for HDR output.** If you tick this box, SilverFast will correct the gamma curve of the file to the specified value, even if you have chosen the linear uncorrected HDR file as your output format. NB: When you build your own scanner profile with the SilverFast IT8 module, note that this value is written into the profile that SilverFast builds. So if you tick this box during the profiling procedure, and again when you subsequently scan a file, it will apply a gamma correction twice. The resulting file may become too bright.

My preference is to set the value to 1.40 during the IT8 profiling procedure, and leave the box unchecked during scanning. The value is not related to the traditional value for screen gamma of 2.2 for Windows systems and 1.8 for Apple computers.

Many settings on these tabs, notably the settings on the **Auto** tab, are not relevant because no processing is performed on the file. NB: All options on the **CMS** tab are set to 'Leave the file alone, please'. On the **Special** tab, note that the option **Super Fine Scan** box is ticked; this is a function of the Nikon LS9000 model that produces higher quality scans, but it does slow the scanner down slightly.

5. The most annoying thing about the **Options** dialogue is that this version of SilverFast, at least on my computer, does not remember the settings. Each and every time you start up SilverFast, you must open **Options** and activate these settings. Fortunately, once you are done, you can save your preferences with **<Save...>** in the **General** tab. You still have to open the **Options** dialogue every time you open SilverFast, but now you can activate all your personal settings at once by clicking on your settings in the drop-down menu; see above.

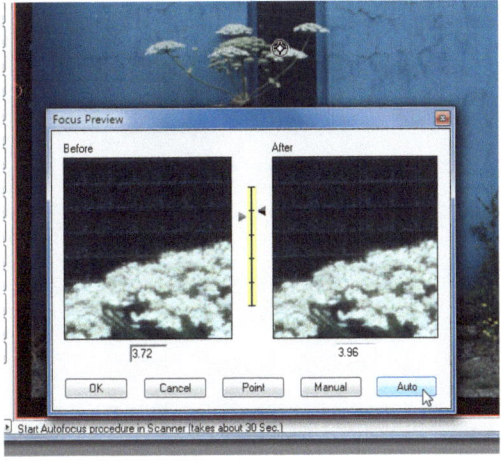

6. Now you have set your options and made a prescan, it is time to focus the scanner. I use a glassless holder, which does not hold the film completely flat. Sometimes this is less than ideal, especially when the film is buckled or I want to scan the last frame of a film strip. With most of my images this is not a problem, because I can focus the scanner on a particular point of interest in the preview, see above. Click **Manual focus setting** and click the pointer on the most important area of the frame. The scanner will create a **Before-After** preview. Click **Auto** and wait for the procedure to finish. Note that **ICE** is still switched off; otherwise this will take a long time. Click **OK** to confirm.

7. Now click on **Digital ICE-Standard.** This option activates an extra infrared scan prior to the optical scan. The infrared beam detects dust and scratches on the film surface and hides them in the final scan, even in the unprocessed 48 bit HDR 'RAW' file you are now producing. This works rather well on this scanner model.

8. Now click on **Scan** in the main dialogue window, choose a folder and enter a file name for the tiff file. Wait for the scanner to finish.

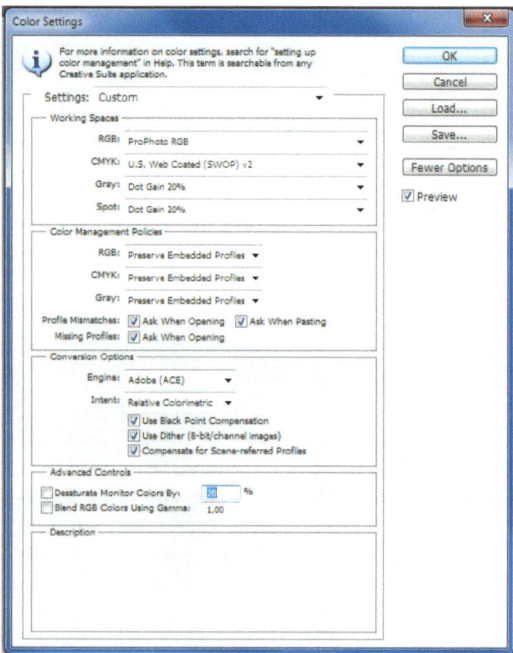

9. Open Adobe Photoshop. From the **Edit** menu, choose **Color settings...** Choose the options as indicated above. I use ProPhoto RGB as my working space. NB: All three **Ask When** boxes are ticked. Click **OK** to confirm.

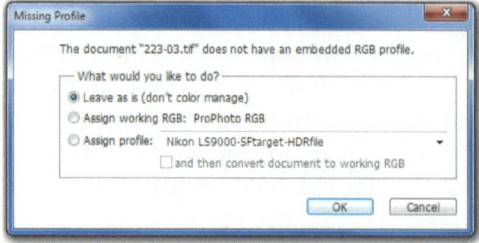

10. Now open the scanned tiff file. The dialogue above will appear first. You could choose the third option in this dialogue and assign the ICC profile that describes your scanner. NB: If you do that, do *not* tick the box **and then convert...** I prefer **Leave as is** at this stage, because I find it instructive to see the untagged file from the scanner. Click **OK**.

16

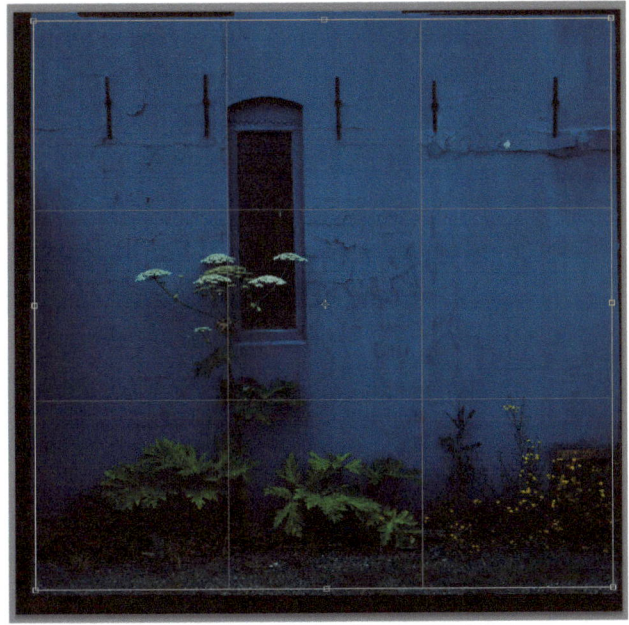

11. Your scan now looks something like this. It looks too dark; don't worry, that is because it is a linear unprocessed file. Activate the **Crop** tool and adjust to crop the black frame edges from the image, see above. NB: The image should contain only 'real' image pixels; otherwise ColorPerfect will misinterpret the data in the next step. Save the image as a tiff file. This is the archived 'RAW' file that you can return to again and again, without having to re-scan the image.

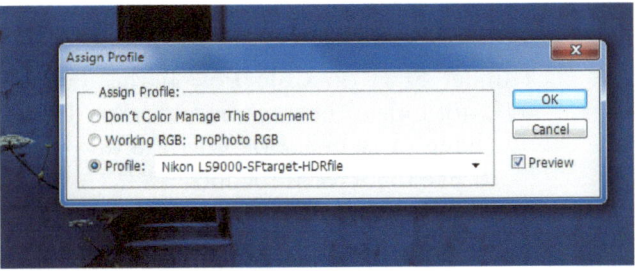

12. If you have not already done so when you loaded the file, assign the profile that you created with the IT8 calibration procedure to the scanned image. In Photoshop, choose **Edit > Assign Profile...** and choose your profile from the drop-down menu. Referring back to the analogy under *Color Management*, in effect this step tells the computer what the 100% is to which the 82% refers. NB: The color information should not change in any way, so do *not* choose **Edit > Convert to Profile...** at this stage.

ColorPerfect-ColorPos

13. You now have a linear (dark) file that you can convert to a gamma-corrected file (lighter) with the Photoshop plug-in **ColorPerfect**. Activate the plug-in by clicking **Filter > CFSystems > ColorPerfect...**

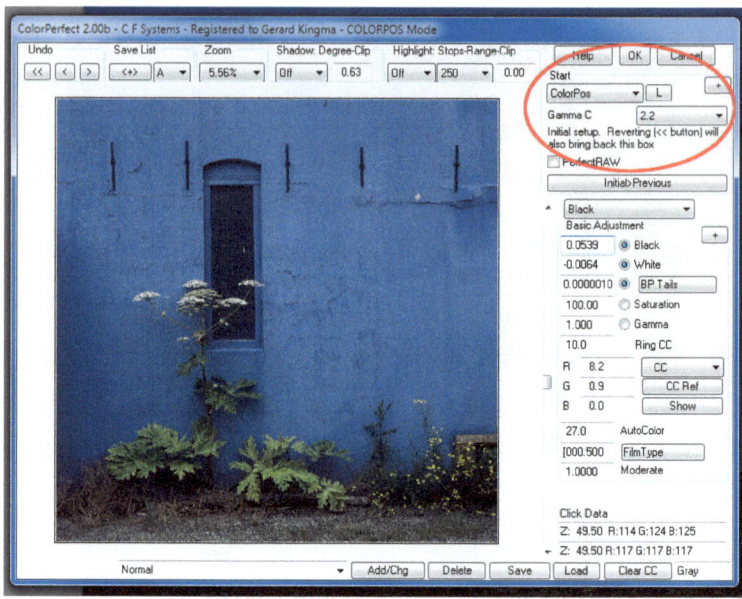

14. Earlier versions of ColorPerfect consisted of separate plug-ins for negative and positive (transparency) scans, called ColorNeg and ColorPos respectively. They have now been integrated in the ColorPerfect plug-in as separate modules. To begin the conversion, activate the relevant module for your purpose; click under **Start** on **ColorPos.** If the dialogue displays a **G** (for Gamma corrected) rather than an **L** (for Linear) next to the ColorPos drop-down menu, press **G** to toggle on **L** (as you are now working on a linear file). In the drop-down menu **Gamma C** choose **2.2**. Your settings should look like the screenshot above.

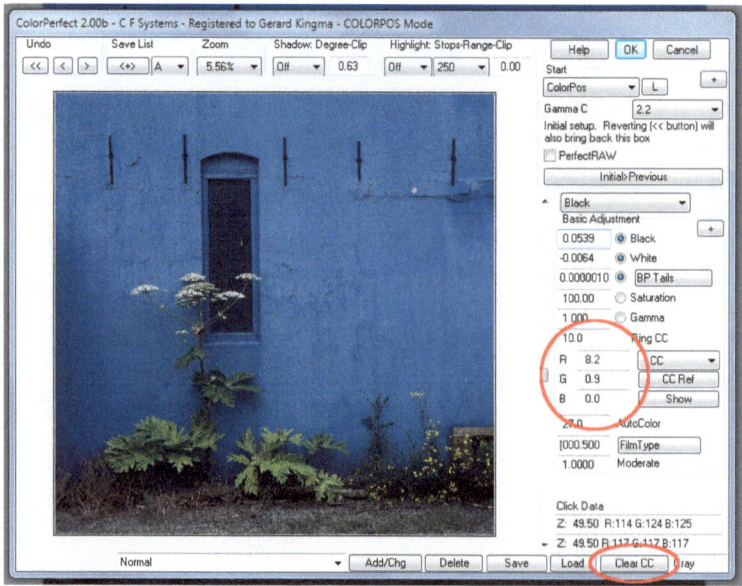

15. ColorPerfect automatically calculates a color correction to correct any color casts. In the previous screenshot, the plug-in adds 8.2 Red and 0.9 Blue. However, as I stated before, I don't want to make any color adjustments at the moment. I only want to extract as much information as possible from the film, without interpreting the data from an aesthetic viewpoint. Click on **Clear CC** at the bottom to clear the color correction. NB: The values for R, G and B are set to 0.0.

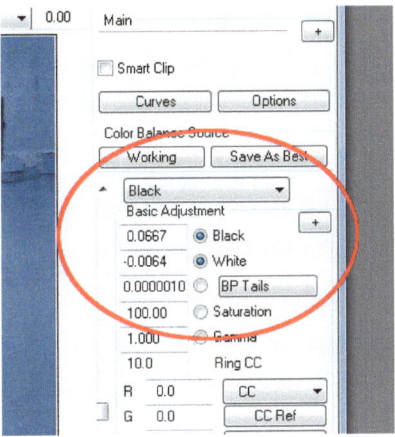

16. Check that only the radio buttons for **Black** and **White** are activated (see above). **BP Tails, Saturation** and **Gamma** are unchecked.

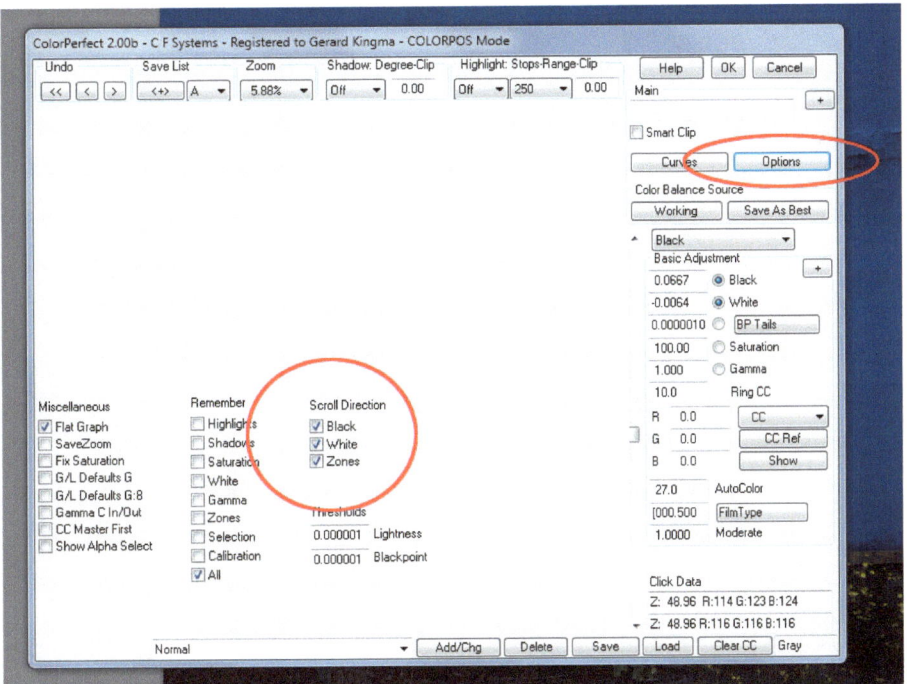

17. Click on **Options** and check the options for **Scroll Direction** as indicated above. Click **Options** again to close the menu.

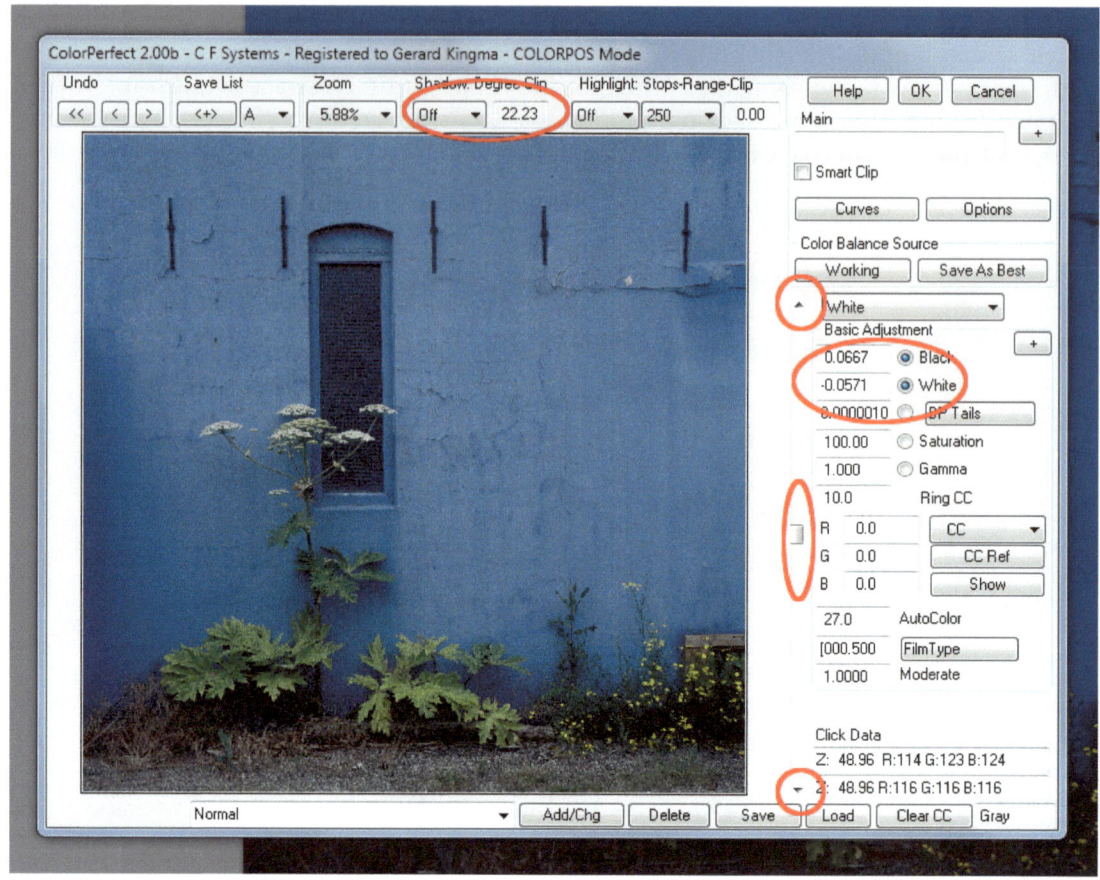

18. Carefully execute the next two crucial steps: setting values for highlight clipping and shadow clipping to 0. Click on the value next to the **White** option. Now you can change this value by dragging the vertical scrollbar to the right of the preview window. The value itself is not relevant. Instead, keep your eyes on the value for **Shadow: Degree-Clip** at the top. When you drag the vertical scroll bar upwards, this value increases and the image becomes darker in the preview window. Drag the scroll bar down again and the image becomes lighter. At some point, the value for **Shadow: Degree-Clip** hits 0.00. Now fine tune the value for **White** by clicking repeatedly on the up and down arrows at both ends of the vertical scroll bar. Click the up arrow to increase the value for **Shadow: Degree-Clip** and then carefully click on the down arrow until the value snaps to 0.00.

This step ensures that the darkest pixels in your image are set to black *without losing shadow detail*.

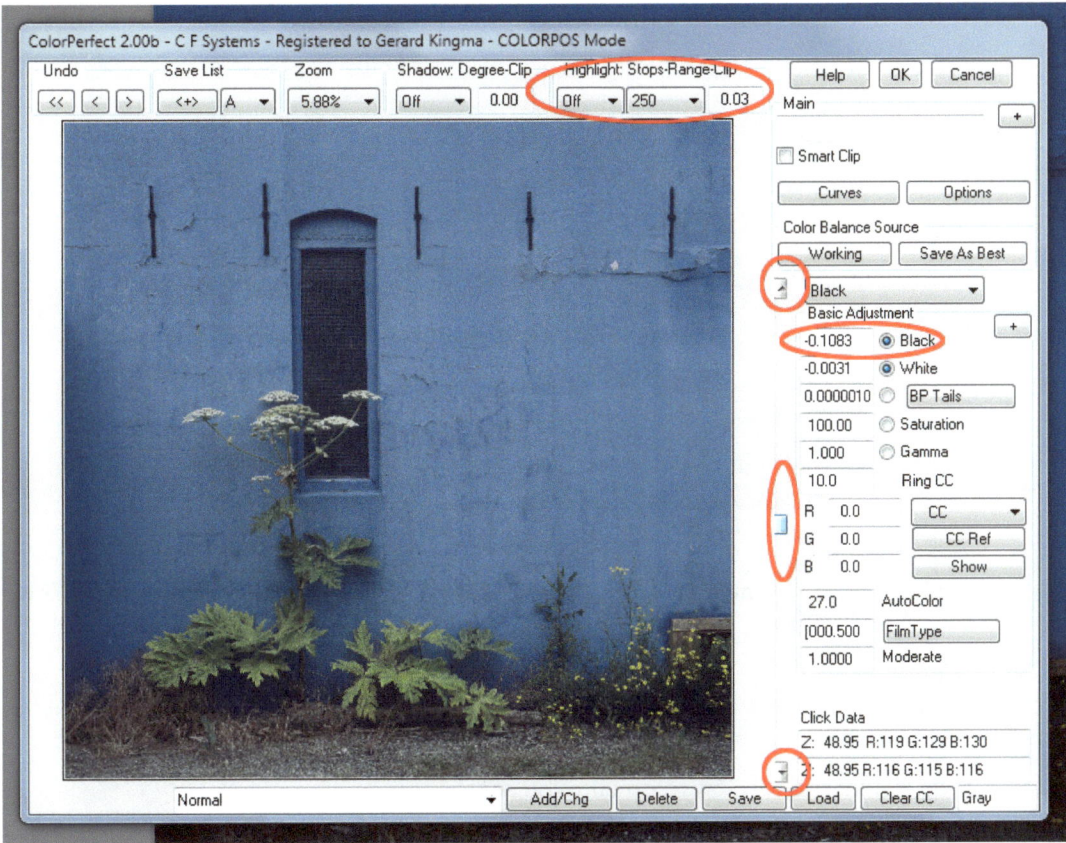

19. Now do the same for the highlights: click on the value next to the **Black** option, see above. Drag the vertical scrollbar upwards to increase the value for **Highlight: Stops-Range-Clip**. The image becomes lighter. Drag the scrollbar down again until the value for **Highlight: Stops-Range-Clip** hits 0.00. As before, fine tune the value for **Black** by clicking on the up and down arrows of the scrollbar to increase the value. Carefully click on the down arrow until the value for **Highlight: Stops-Range-Clip** just hits 0.00.

This step ensures that the lightest pixels in your image are set to white *without losing highlight detail.*

With some images you will have to repeat these steps. Sometimes, when you have set the **Shadow: Degree-Clip** to 0.00, and then set **Highlight: Stops-Range-Clip** to 0.00, the value for **Shadow: Degree-Clip** increases again. In that case you have to fine tune the value for **White** again until the value for **Shadow: Degree-Clip** snaps back to 0.00.

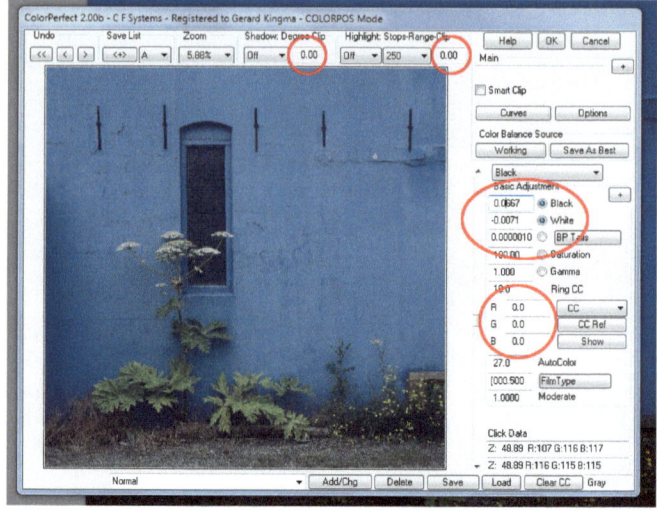

20. The plug-in window now looks like the screenshot above. You have set R, G, B color correction to 0.0 and adjusted the (seemingly arbitrary) values for **Black** and **White** so that the clipping values for shadows and highlights have snapped to 0.00.

Again, what you have done is ask the plug-in to extract all possible detail without aesthetically interpreting the image and without clipping shadows and highlights.

Click **OK** at the top of the window to execute the conversion.

21. Now I usually convert the image from the profile that describes the scanner to the working space, which I set to ProPhoto RGB as described in step 9 above. In the Photoshop menu, click **Edit > Convert to Profile...**

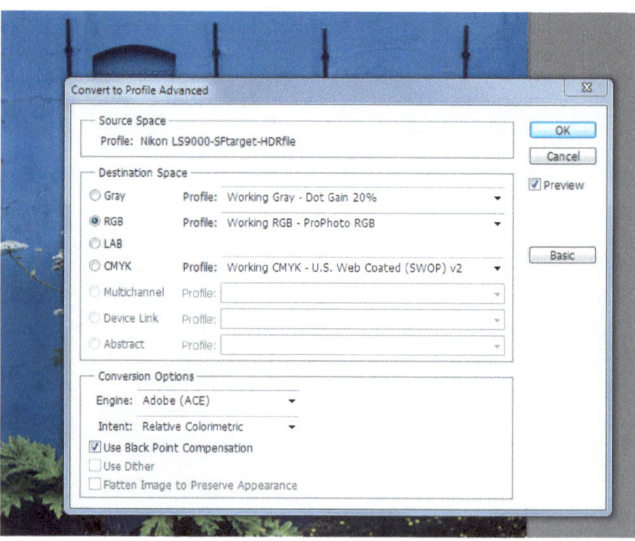

Choose the settings as indicated on the screenshot above and click **OK**.

22. You have now reached the first goal. You have captured as much data as possible from the original film, without interpreting the file, and without losing shadow or highlight detail. But precisely because of this, the image may look dull or flat; more often than not, it lacks contrast.

Post-processing: From capture to interpretation

It is time to go to the next step, which is subjective processing. It is the photographer's privilege, or duty, to post-process the image to make it come to life. To help us do this, Photoshop offers many tools to adjust contrast, brightness and color saturation (down to black and white). I regard this as an iterative process. I make repeated color and contrast corrections until I am happy with the result, and then save the file. Usually, when I open the same file again the next day, I find that I need to fine tune the color balance or contrast some more, or I want to emphasize some areas of the image at the expense of others.

That's why I choose to post-process the image with adjustment layers in Photoshop. As I said earlier, I don't want to make any subjective choices about color balance or contrast during the scanning process, because if I changed my mind about the 'look' of the image, I would have to scan the image all over again.

If I leave the source image alone and make corrections in adjustment layers, I can save the original image together with these adjustment layers. If I change my mind about the look of the image or want to fine tune the color balance, saturation or contrast, I can edit the adjustment *at any time* without changing the original scan. The procedure below differs to some extent from the example in *Workflow 2: Scanning negatives on the Epson V750*, so you might want to read that workflow description as well.

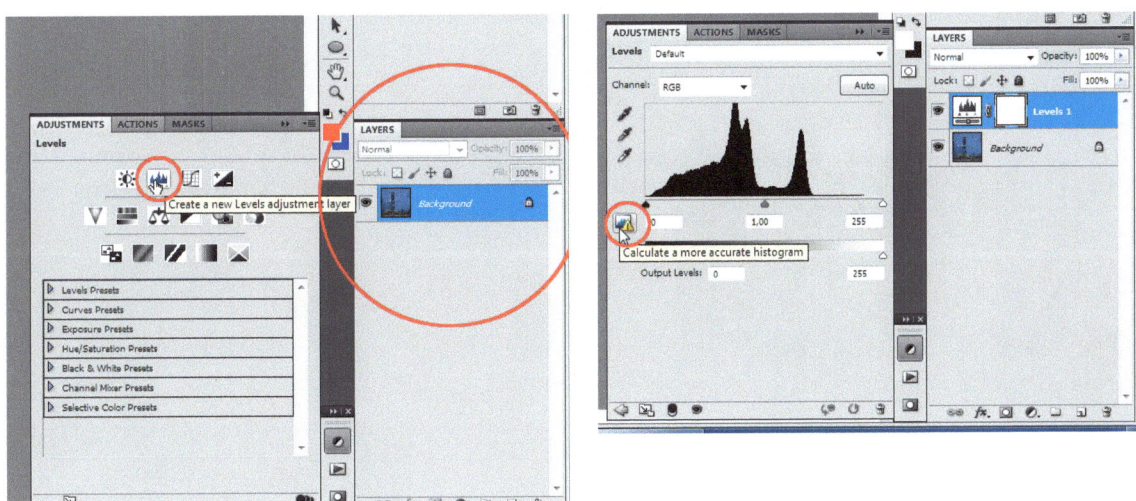

23. There are many options for adapting the Photoshop interface to your personal preferences. I find it convenient to have the **Layers** window in the lower right corner of the screen, with the **Adjustments** palette next to it. Now create a **Levels** adjustment layer, see above. In the **Adjustments** window, click on the warning triangle to calculate an accurate histogram.

I usually start by color balancing the image. I prefer a **Levels** adjustment layer to a **Color Balance** adjustment layer, because **Levels** gives me more control over the separate adjustment of shadow, midtone and highlight color casts.

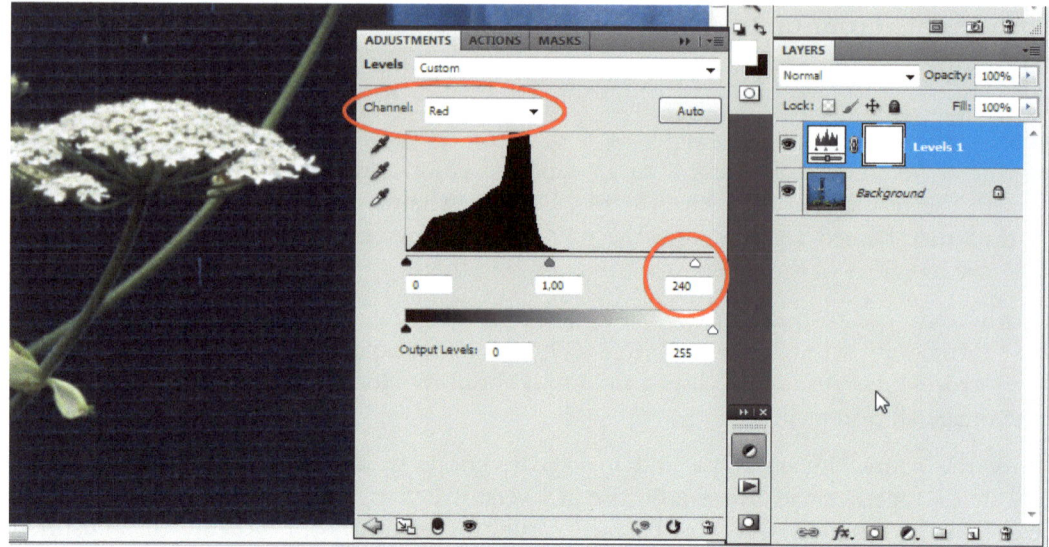

24. In the example above, I zoom in at 50% on the highlights (the white flowers of the giant hogweed). In the **Adjustments** window, I activate the **Red** channel in the **Channel** drop-down menu and slide the highlight slider to the left, from 255 to 240, to correct for a green cast in the highlights. Note I am eyeballing this adjustment. It is an adjustment to taste. There is no science involved, but it does require a calibrated monitor of good quality.

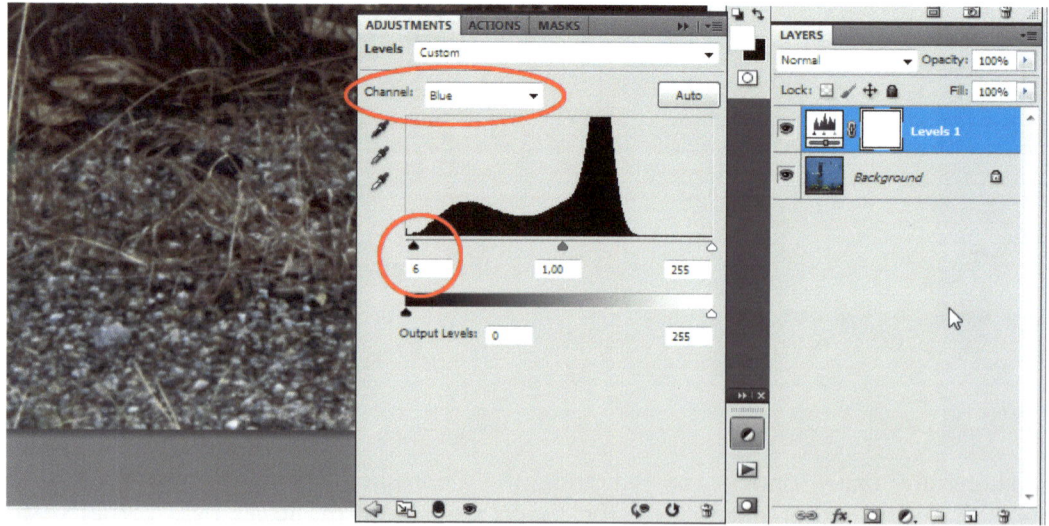

25. Next I scroll down in the image to the gravel. I activate the **Blue** channel from the **Channel** menu and slide the shadows slider to the right, from 0 to 6, to correct for a blue cast in the shadows.

For each of the two basic color cast corrections (shadows and highlights), I correct two of the three channels. I might for instance correct red and blue in the shadows, and green and blue in the highlights. Usually I don't make corrections in all three color channels.

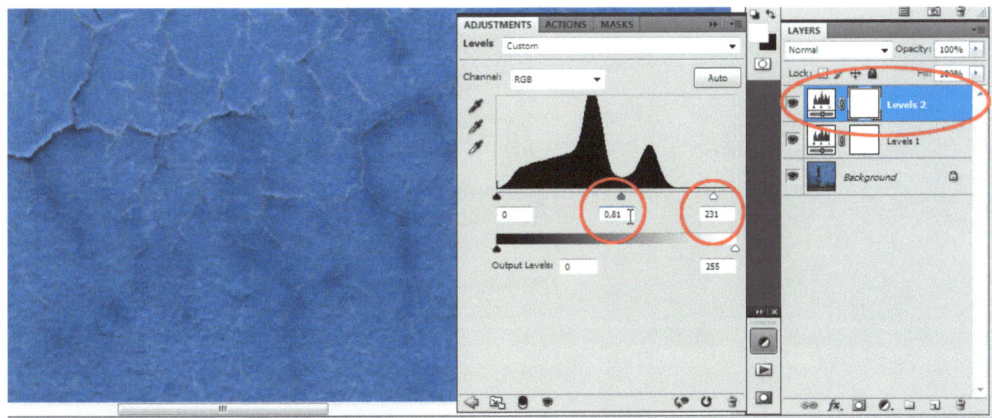

26. To bring out the texture of the blue wall, I decide to increase the contrast. I find that a **Levels** layer gives me more control than a **Brightness/Contrast** adjustment layer, so I make a new **Levels** adjustment layer and click on the warning triangle to calculate a histogram. I compress the histogram by dragging the highlight slider to the left from 255 to 231 and the midtone slider to the right, from 1.00 to 0.81.

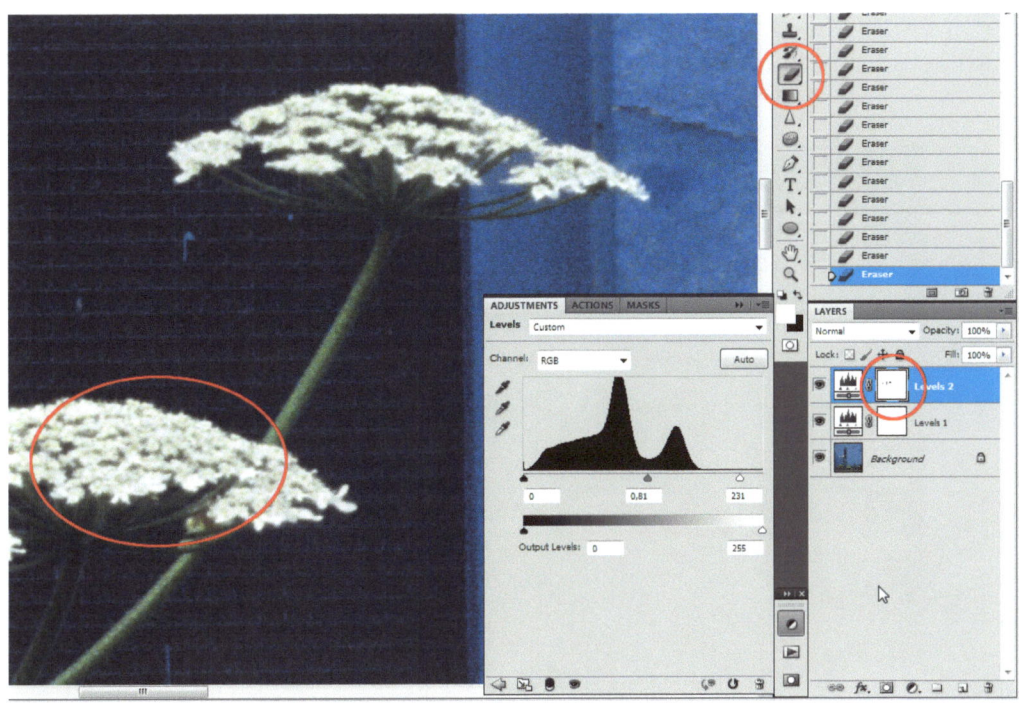

27. I like the contrast enhancement on the stucco, but unfortunately this has blown out the whites on the flowers. I can undo this as follows: Click on the layer mask to activate it (see above, the red circle in the **Layers** window). Choose the **Eraser** tool from the tools menu (the red circle at the top) and locally brush out the **Levels** adjustment on the flowers. The foreground color must be set to white and the background color to black for this to work.

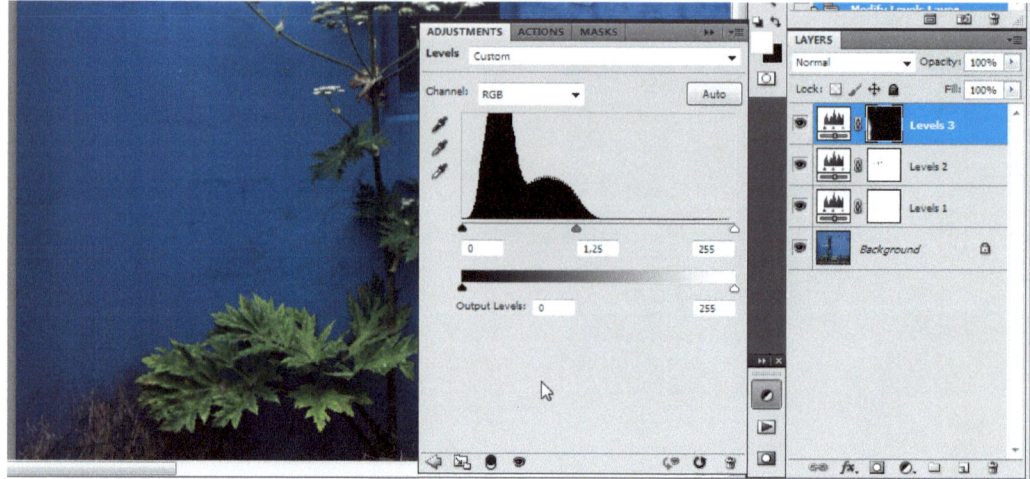

28. Just outside the frame on the left of the house, there was a fence which cast a shadow over the blue wall. I decide to lighten this up to make it less distracting. I open a third **Levels** layer and slide the midtone pointer to the left from 1.00 to 1.25. In the layer mask, I brush out most of the frame, leaving only the shadow area to be influenced by the adjustment layer.

As you can see from these examples, the possibilities for adjusting color balance, brightness and contrast are virtually limitless, both globally and locally, just by applying a couple of **Levels** layers and brushing out areas in the layer mask where I don't want to apply the adjustment.

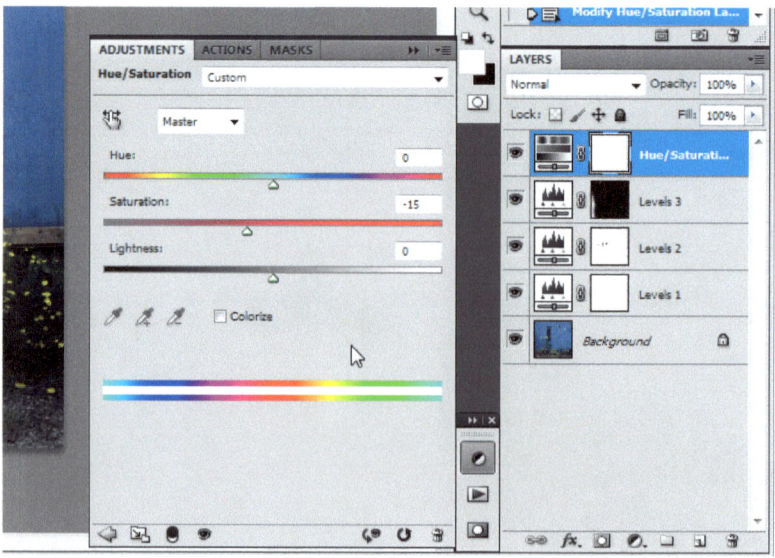

29. To finish the post-processing, I add a **Hue/Saturation** adjustment layer and reduce the **Saturation** to -15, to make the colors slightly less garish. You can adjust individual colors by clicking on the pointer in the **Master** drop-down menu and selecting the appropriate color. For instance, this lets you adjust the saturation of the green leaves independently from the saturation of the blue wall.

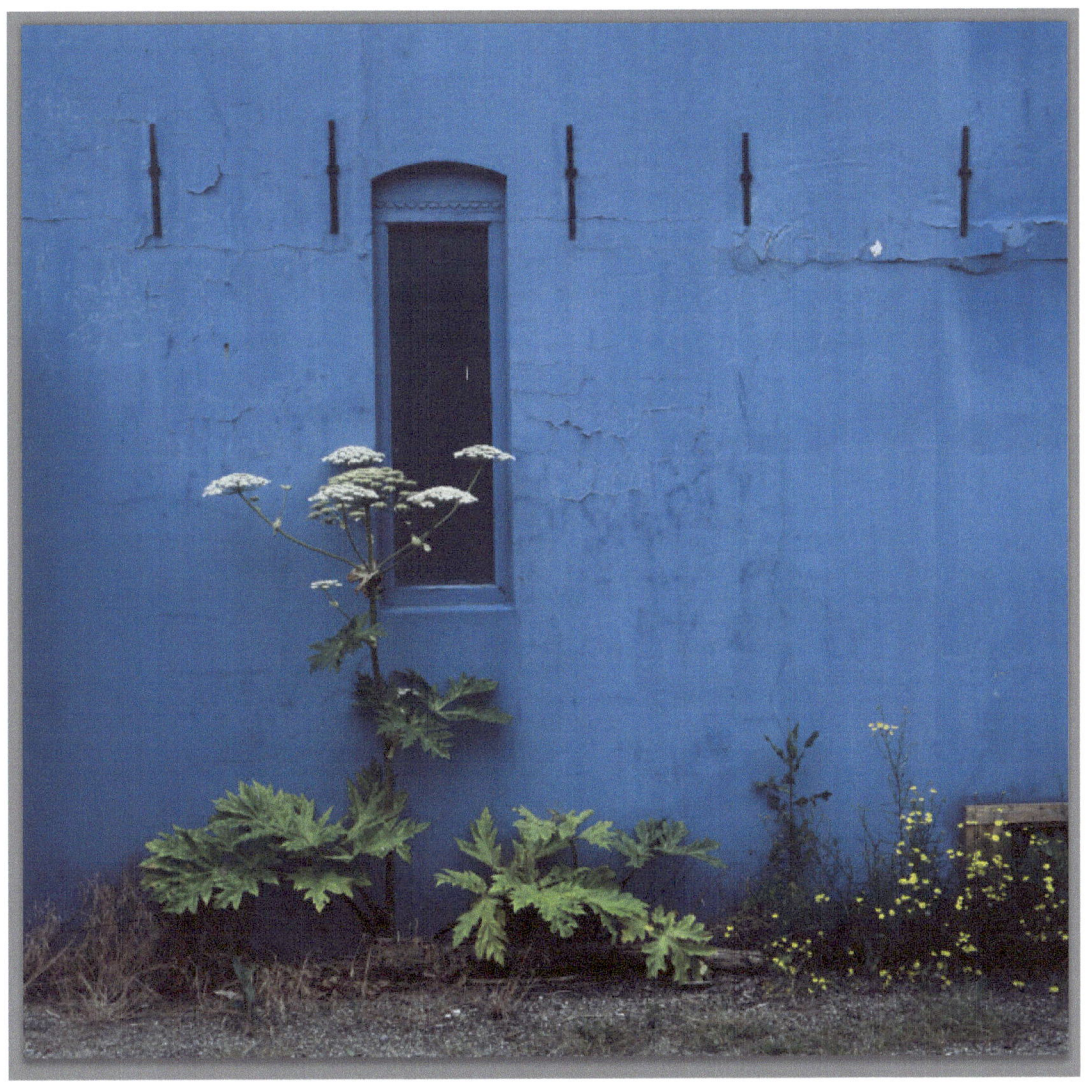

30. Now save the image as a.psd file, which is the native Photoshop format. All adjustment levels are saved together with the image. I can re-open the file at any time and open any adjustment layer to fine tune any correction that I may have changed my mind about, without affecting the original scan.

Workflow 2: Scanning negative film on an Epson V750 with VueScan

This workflow describes the process of scanning a negative medium format roll film on the Epson V750 with VueScan. For this tutorial I have chosen an image of a Scottish Highlander cow in a frosty field at dawn, shot with a Hasselblad 501CM on Kodak Portra 160nc.

As I described in the introduction on color management, it is essential that you obtain a profile that describes the behavior of your scanner. I would recommend ordering a calibration target from Wolf Faust at www.targets.coloraid.de. In VueScan, on the **Input** tab choose **Task: Profile scanner.** Follow the instructions in the VueScan manual to build the profile.

1. After you have profiled your scanner, load the film into the film holder. The Epson manual advises you to insert the film with the emulsion facing upwards. However, I find that scanning the film with the emulsion facing down produces better scans. Place the film holder on the scanner.

2. Start VueScan. Choose the various settings as indicated on the tabs above. I won't discuss every single option, because many are personal preferences and most are described in the VueScan online manual. I will point out options and settings that I find important to reach my goal: to extract objectively the maximum amount of detail present in the original medium, in both highlight and shadow areas, without imposing a subjective interpretation on how the image should look on screen or in print.

On the **Input** tab, choose **Task: Scan to file**. In **Media**, choose **Image**. Set **Bits per pixel** to **48 bit RGB**. Set **Scan resolution** to **3200 dpi**. According to the Epson specifications, the scanner is capable of scanning at 6400 dpi, but in the tests I did, I couldn't see any extra relevant detail in scans at resolutions higher than 3200 dpi – the files merely get bigger. NB: Make sure that **Lock exposure** is unchecked before you press **Preview**.

On the **Crop** tab, check that **Preview area** is set to **Maximum**. This ensures that the preview will scan the entire film holder, so that you can select the desired frame.

On the **Filter** tab, I set **Infrared clean** to **None,** because I find that the infrared dust and scratch function does not work very well on the Epson V750; it can adversely affect fine detail. On the Nikon LS9000 this function (ICE) works quite well. Other functions that affect the image data, such as **Grain reduction** and **Sharpen,** are switched off.

On the **Color** tab, set **Color balance** to **None.** Directly below this option you will find various options for color management. These are not that relevant, as I assign the correct profile to the scanned image after I have opened the image in Photoshop.

When you check **Pixel colors** on the **Color** tab, the Preview image will warn you of clipped shadows and highlights by marking them in the colors that you choose from the drop-down menu. I set these to the colors that I know from the Camera RAW interface in Photoshop: blue for clipped shadows and red for clipped highlights. For the Nikon LS9000, I set the **Infrared detection color** to green so that any dust will show up in the preview area as green spots. This will only show up when you activate the **Infrared clean** option on the **Filter** tab (set to Light/Medium/Heavy).

On the **Output** tab, I only check **Raw file.** For **Raw file type,** choose **48 bit RGB.** Set **Raw output with: Scan**, otherwise VueScan will apply the profile before writing the data. If you subsequently assign the scanner profile in Photoshop, it will be applied twice, resulting in incorrect colors. Uncheck **Raw save film** for the same reason.

The **Prefs** tab contains many options that mostly depend on user preference. I set **Graph type** to **Raw**. This displays a histogram of the unprocessed scan in the lower left corner of the dialogue window, which is very helpful for checking the scanner exposure.

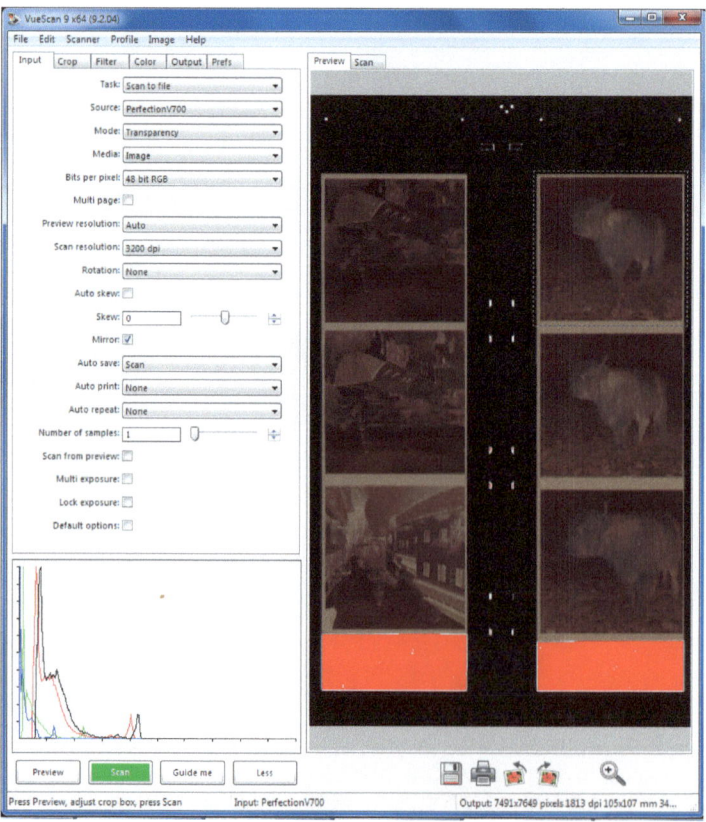

3. Now click on **Preview.** The preview window will display an image of the entire film holder. The red areas indicate blown highlights.

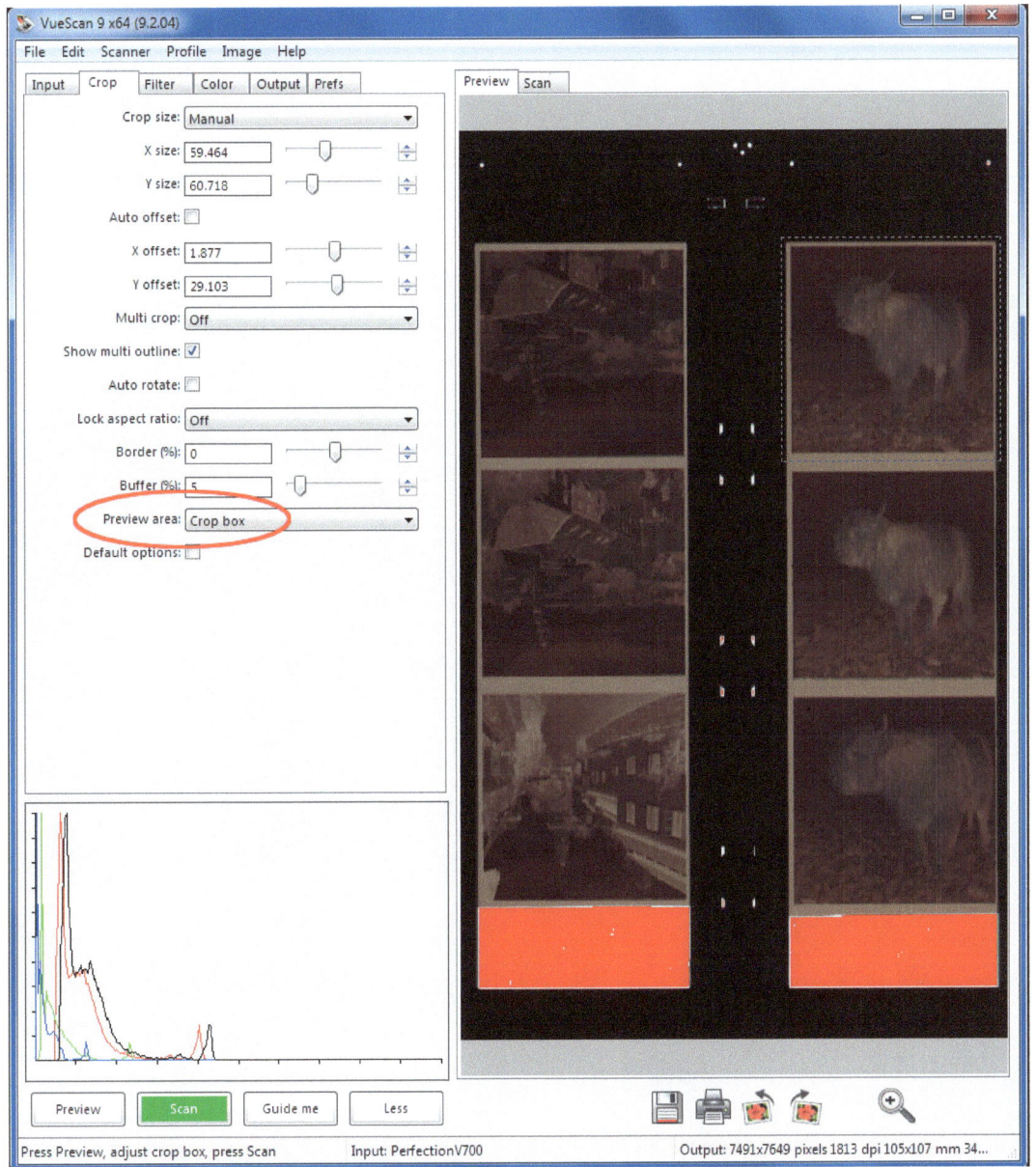

4. Drag a crop box around the frame you wish to scan, in this example the first of the three frames in the film strip to the right. On the **Crop** tab, the setting for **Crop size** automatically changes from **Maximum** to **Manual.** Now change the setting for **Preview area** to **Crop box.** Click **Preview** again to make a preview of the selected frame.

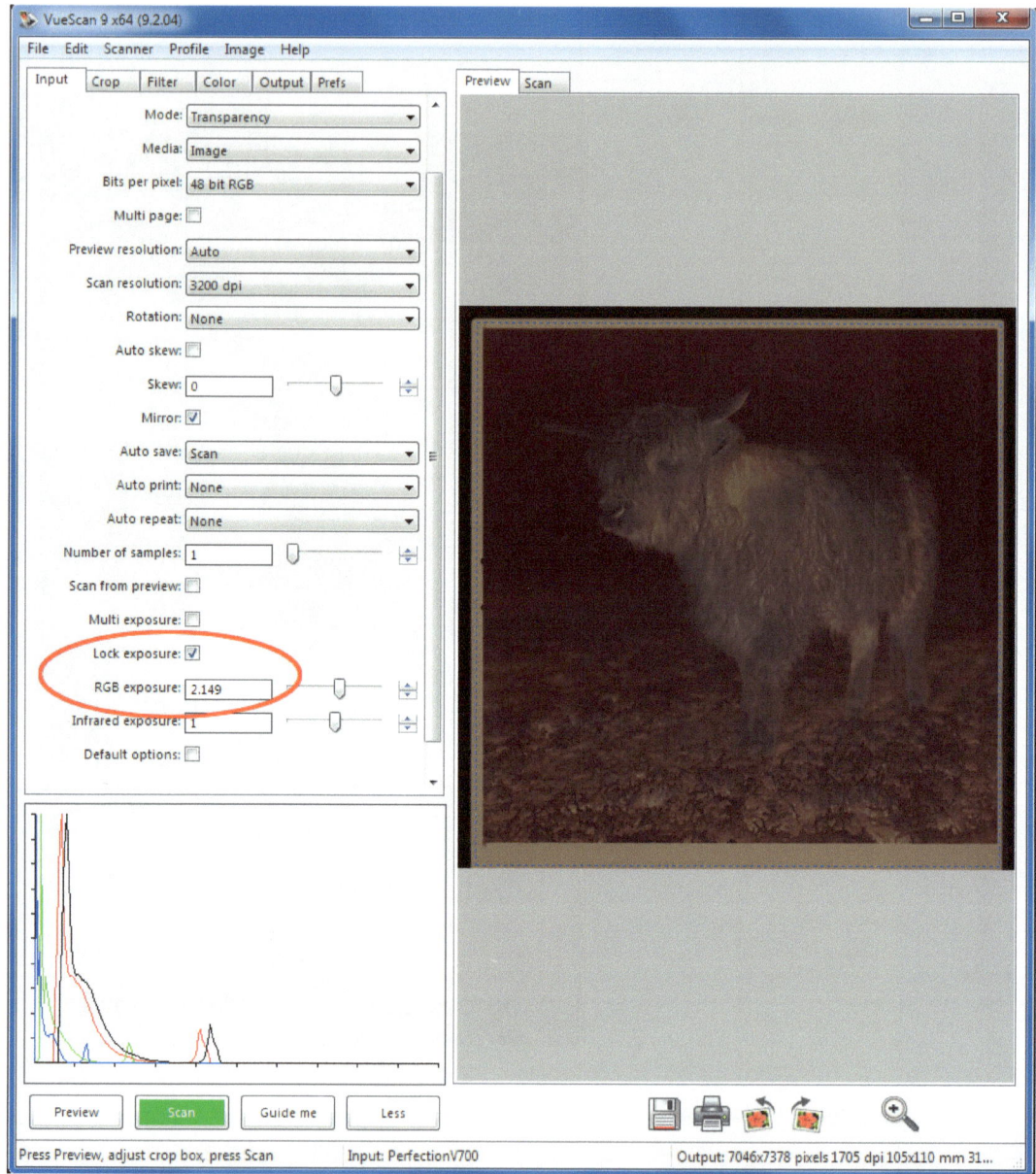

5. The next step is to determine the optimum scanner exposure for this frame. Carefully adjust the crop box so that the entire frame is selected, including the unexposed film frame edges, but take care to exclude the black film holder edges (see the preview window above). On the **Input** tab, check **Lock exposure.** The scanner then calculates that the best exposure setting for this frame is 2.149. This is not an absolute value; it is relative to the last preview generated. That's why I always make the first preview with **Lock exposure** unchecked.

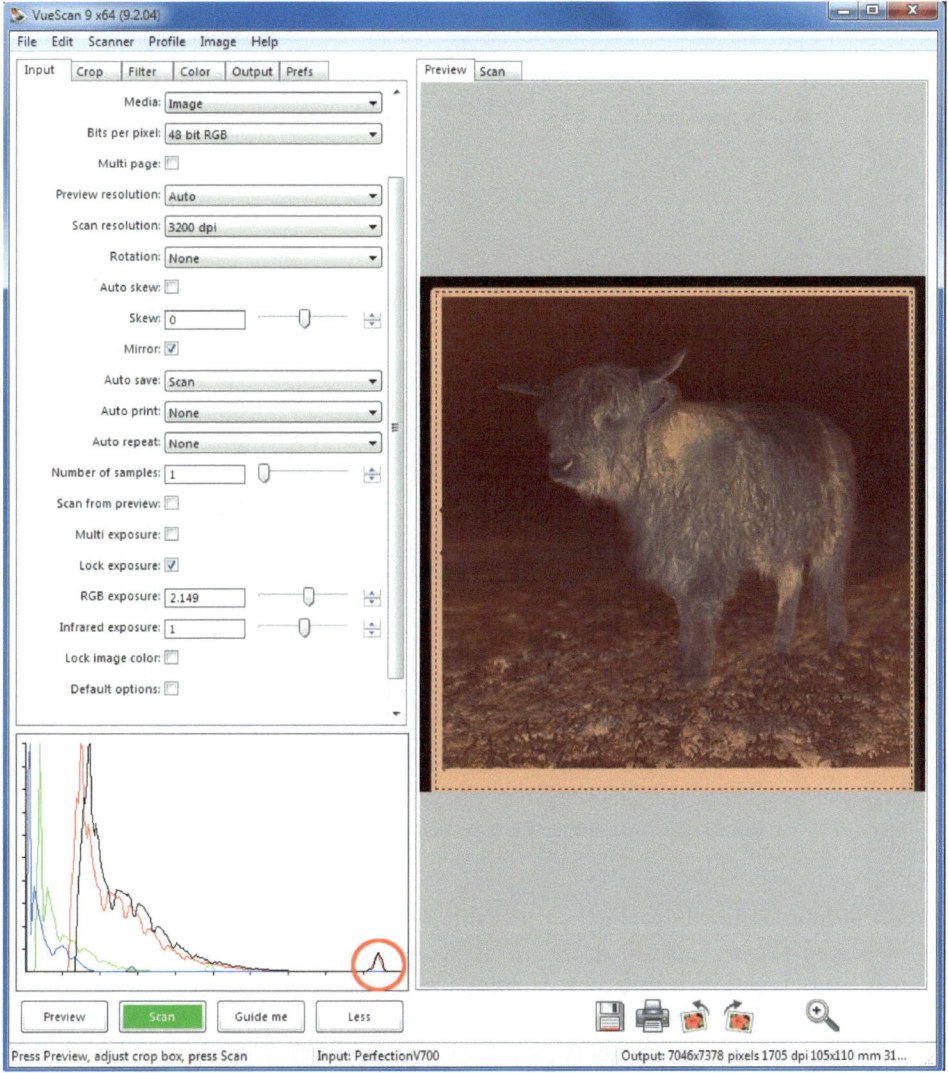

6. You have to refresh the preview to update the exposure, so click **Preview** again. You can check the new setting by studying the histogram. The unexposed edge of the film should not be blown out; the red 'blip' representing the film edge should be near the right of the histogram (note the red circle in the screenshot above). If you do not include the unexposed frame edge in the crop box, the scanner will likely set the scanning exposure too high, as a result of possibly blown out highlights.

7. NB: Unlike the Nikon LS9000, the Epson V750 does not provide a focusing function. However, the film holders for this model contain nine plastic height adjusters. You can set three different film distances with these studs: you can remove the studs, you can insert them with the arrow pointing to the + sign and you can insert them reversed, pointing to the O sign. Each of these orientations changes the distance between the film holder and glass plate, or rather the lens inside the scanner. This gives you some control over the focusing distance. Experiment to find the configuration that works best for you; I set mine to the + sign (with the film emulsion facing downwards).

8. Now click **Scan.** When the scanner is finished, save the scan as a tiff file.

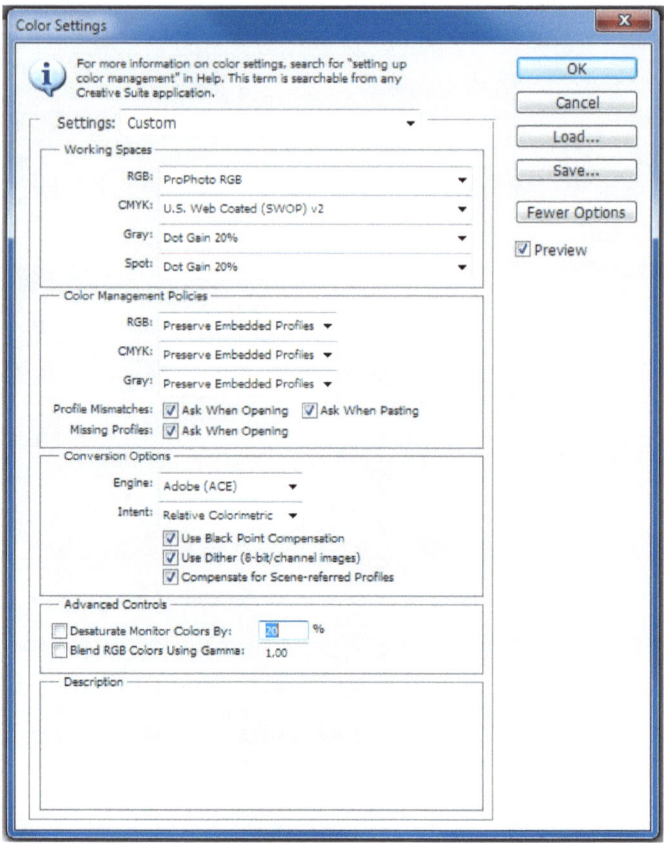

9. Open Adobe Photoshop. From the **Edit** menu, choose **Color settings...** Choose the options as indicated above. I use ProPhoto RGB as my working space. Note that the three **Ask When...** boxes are ticked. Click **OK** to confirm.

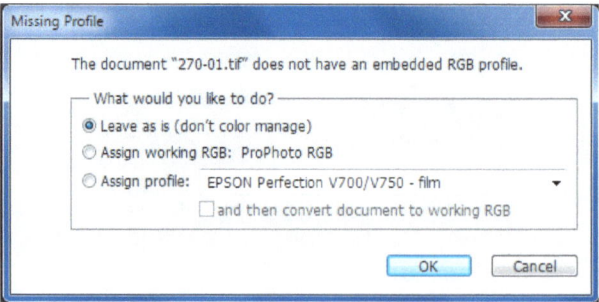

10. Now open the scanned tiff file. The dialogue above appears first. You could choose the third option in this dialogue and assign the ICC profile that describes your scanner. NB: If you do that, do *not* tick the box **and then convert...** I prefer **Leave as is** at this stage, because I find it instructive to see the untagged file from the scanner. Click **OK**.

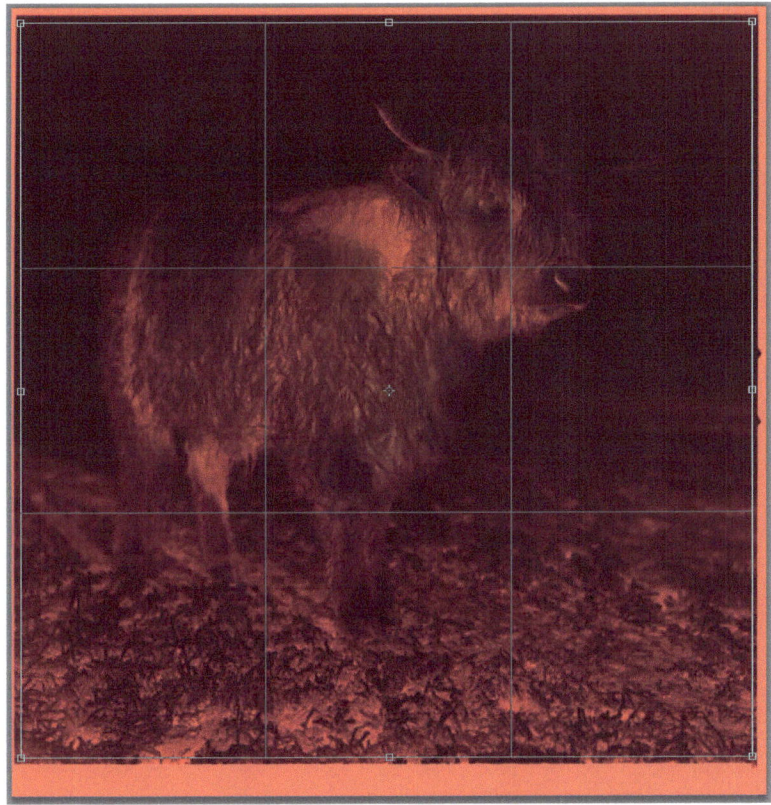

11. Your scan now looks something like this. Activate the **Crop** tool and adjust to crop the light orange frame from the image, see above. It is important that the image contains only 'real' image pixels, otherwise ColorPerfect will misinterpret the data in the next step. Save the image as a tiff file. This is the archived 'RAW' file that you can return to again and again, without having to re-scan the image.

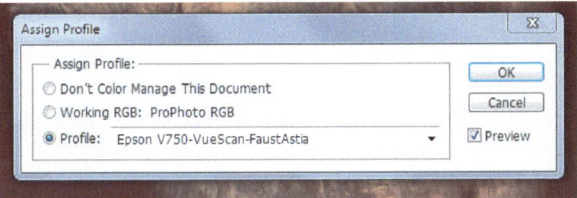

12. If you have not already done so when you loaded the file, assign the profile that you created with the IT8 calibration procedure to the scanned image. In Photoshop, choose **Edit > Assign Profile...** and choose your profile from the drop-down menu. Referring back to the analogy under **Color Management,** this step in effect tells the computer what the 100% is to which the 82% refers. NB: The color information should not change in any way, so do *not* choose **Edit > Convert to Profile...** at this stage.

35

ColorPerfect – ColorNeg

You now have a linear negative file that you can convert to a positive file with the Photoshop-plug-in **ColorPerfect**. Activate the plug-in by clicking **Filter > CFSystems > ColorPerfect...**

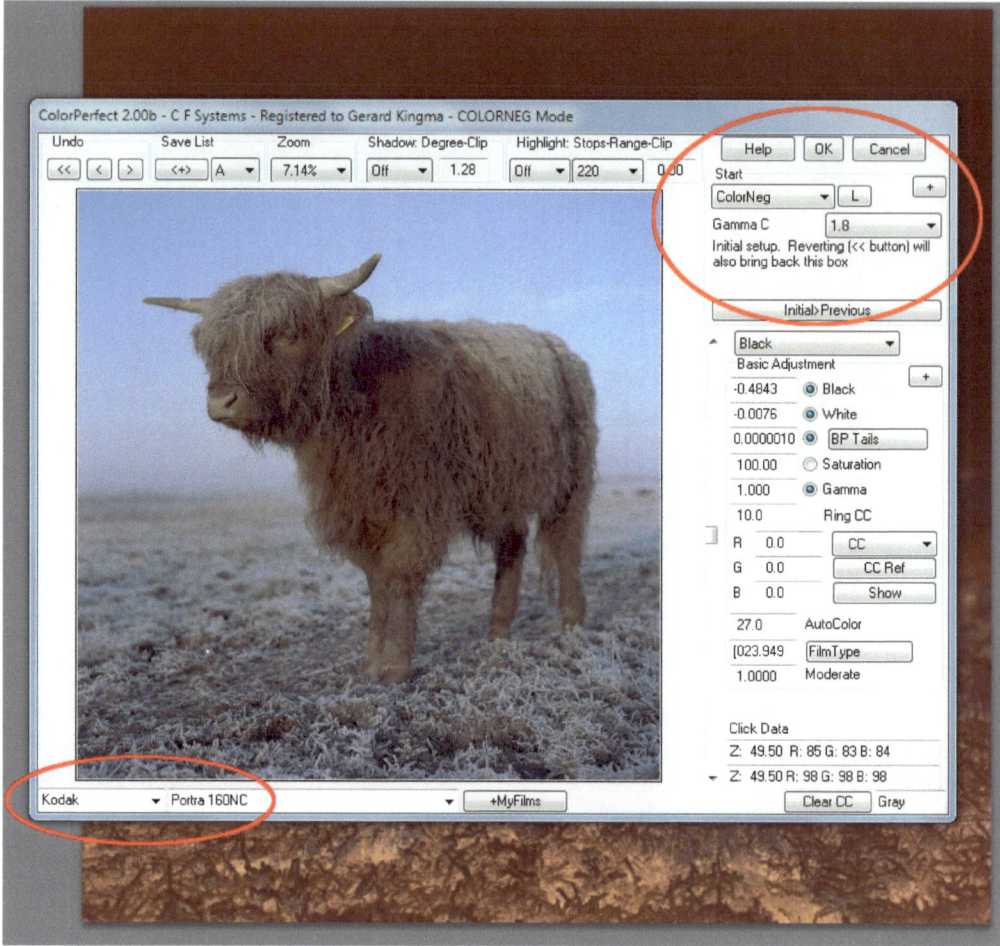

13. Earlier versions of ColorPerfect had separate plug-ins for negative and positive (transparency) scans, called ColorNeg and ColorPos. They are now integrated in the ColorPerfect plug-in as separate modules. To begin the conversion, activate the relevant module for your purpose; click under **Start** on **ColorNeg.** If the dialogue displays a **G** (for Gamma corrected) rather than an **L** (for Linear) next to the ColorNeg drop-down menu, press **G** to change it to **L** (as you are now working on a linear file). In the drop-down menu **Gamma C** choose **1.8**. The best value for this parameter depends to some extent on the original exposure; experiment to see which works best. The setting is not related to the traditional screen gamma values of 2.2 for Windows systems and 1.8 for Apple Mac computers. Your settings should look like the screenshot above.

14. From the two drop-down menus below left, choose your film brand and type –Kodak Portra 160NC in this example. This option will correct for the orange mask of the film.

15. Check that only the **Black** and **White** buttons are activated (see above). **BP Tails, Saturation** and **Gamma** are unchecked.

16. Click on **Options** and check the options for **Scroll Direction** as indicated above. Click **Options** again to close the menu.

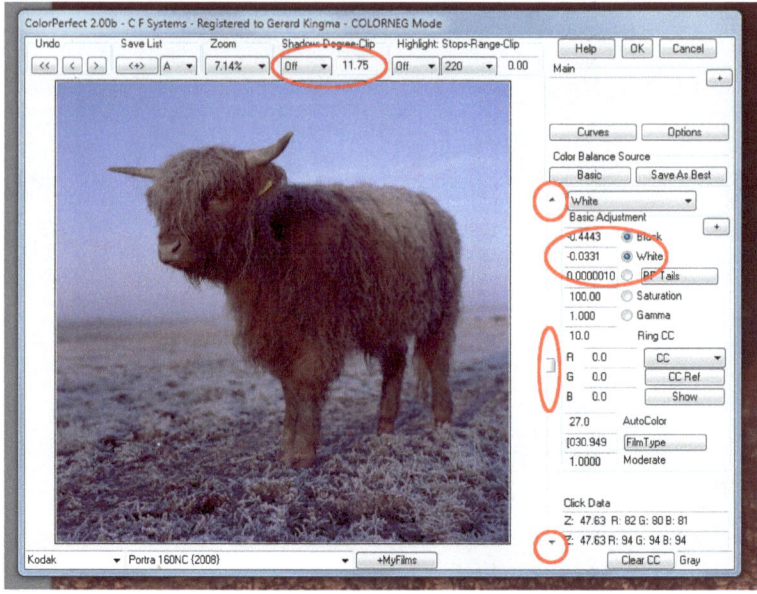

17. Carefully execute the next two crucial steps: setting the values for highlight clipping and shadow clipping to 0. Click on the value next to the **White** option. Now you can change this value by dragging the vertical scrollbar on the right of the preview window. The value itself is not relevant. Instead, keep your eyes on the value for **Shadow: Degree-Clip** at the top. When you drag the vertical scroll bar upwards, this value increases and the image becomes darker in the preview window. Drag the scroll bar down again and the image becomes lighter. At some point, the value for **Shadow: Degree-Clip** hits 0.00. Now fine tune the value for **White** by clicking repeatedly on the up and down arrows at both ends of the vertical scroll bar. Click the up arrow to increase the value for **Shadow: Degree-Clip** and then carefully click on the down arrow until the value snaps to 0.00.

This step ensures that the darkest pixels in your image are set to black *without losing shadow detail.*

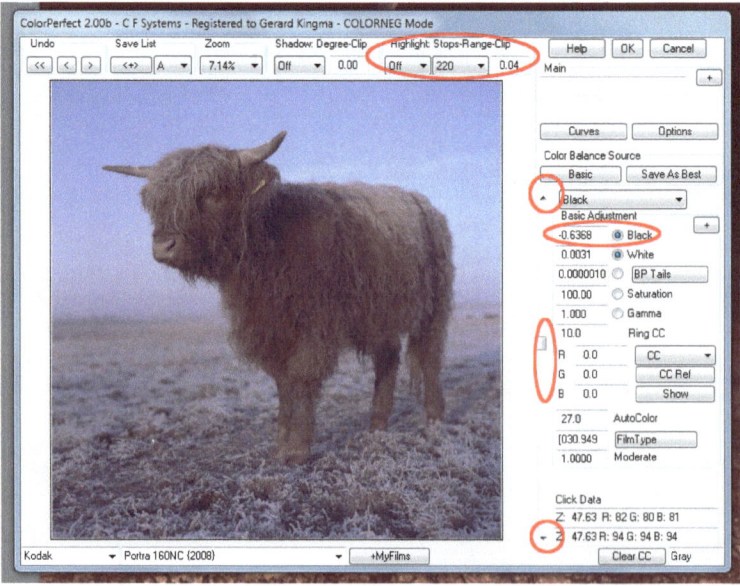

18. Now do the same for the highlights: click on the value next to the **Black** option, see above. Drag the vertical scroll bar upwards to increase the value for **Highlight: Stops-Range-Clip**.

The image becomes lighter. Drag the scrollbar down again until the value for **Highlight: Stops-Range-Clip** hits 0.00. As before, fine tune the value for **Black** by clicking on the up and down arrows of the scroll bar. Carefully click on the down arrow until the value for **Highlight: Stops-Range-Clip** just hits 0.00.

This step ensures that the lightest pixels in your image are set to white *without losing highlight detail.*

With some images you will have to repeat these steps. Sometimes, once you have set **Shadow: Degree-Clip** to 0.00, and subsequently set **Highlight: Stops-Range-Clip** to 0.00, the value for **Shadow: Degree-Clip** increases again. In that case you have to fine tune the value for **White** again until the value for **Shadow: Degree-Clip** snaps back to 0.00.

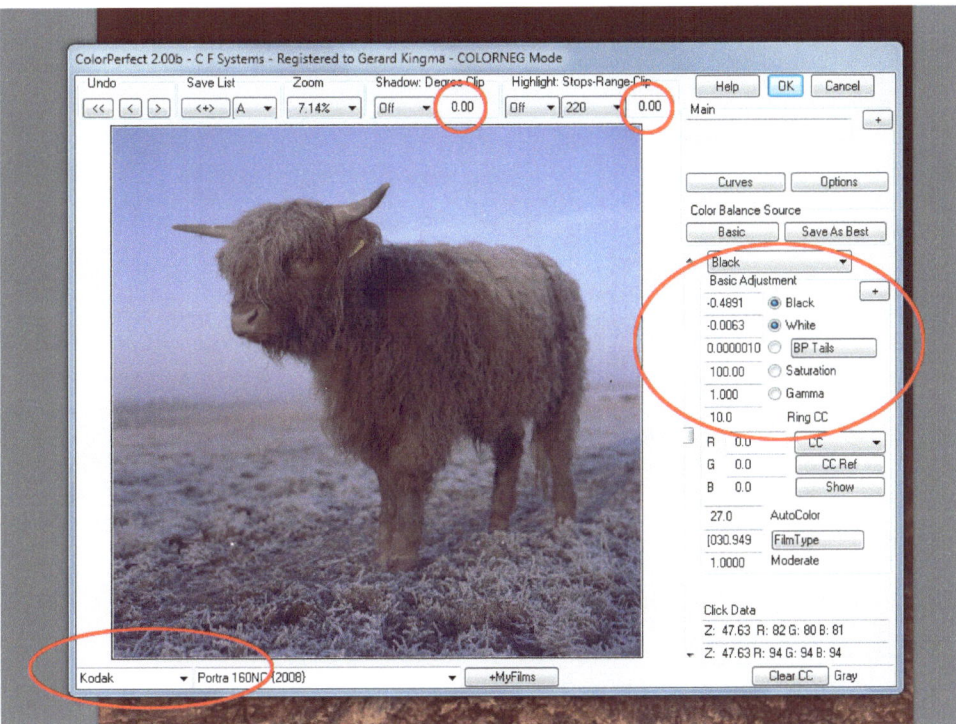

19. The plug-in window now looks like the screenshot above. You have set your film brand and type and adjusted the (seemingly arbitrary) values for **Black** and **White** so that the clipping values for shadows and highlights have snapped to 0.00.

Again, what you have done is ask the plug-in to extract all possible detail without aesthetically interpreting the image and without clipping shadows and highlights.

Click **OK** at the top of the window to execute the conversion.

Now I usually convert the image from the profile that describes the scanner to the working space, which I set to ProPhoto RGB back in step 9 above. In the Photoshop menu, click **Edit > Convert to Profile…**

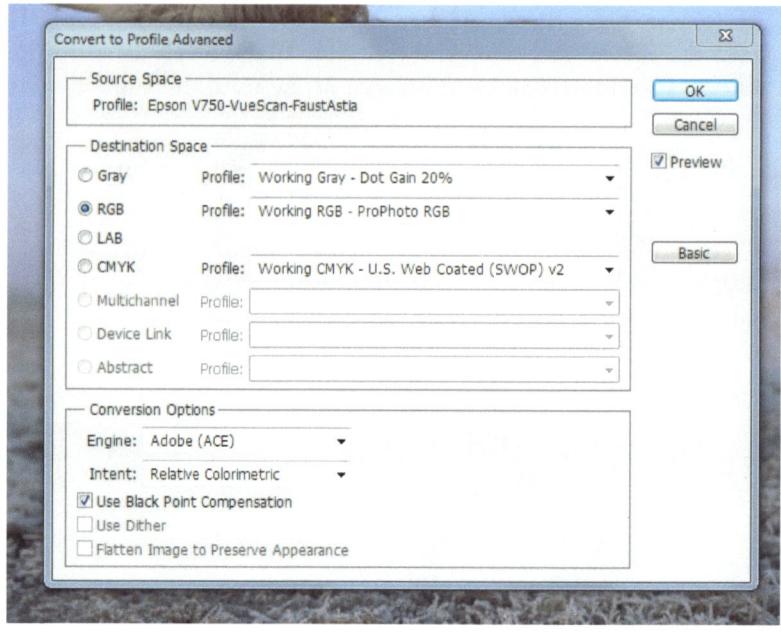

Choose the settings as indicated on the screenshot above and click **OK**.

20. You have now reached the first goal: You have captured as much data as possible from the original film, without interpreting the file, and without losing shadow or highlight detail. But precisely because of this, the image may look dull or flat. More often than not, it lacks contrast and the color balance may be off.

Post-processing: From capture to interpretation

It is time to go to the next step, which is subjective processing. It is the photographer's privilege, or duty, to post-process the image to make it come to life. Photoshop offers many helpful tools for this, to adjust contrast, brightness, color balance and saturation (down to black and white). I regard it as an iterative process. I make color and contrast corrections until I am pleased with the result, and then save the file. Usually, when I open the same file again the next day, I find that I need to fine tune the color balance or contrast some more, or I want to emphasize some areas of the image at the expense of others.

That's why I choose to post-process the image with adjustment layers in Photoshop. As I said earlier, I don't want to make subjective choices about color balance or contrast in the scanning process, because if I changed my mind about the 'look' of the image, I would have to scan the image all over again.

If I leave the source image alone and make corrections in adjustment layers, I can save the original image together with these adjustment layers. If I change my mind about the look of the image or want to fine tune the color balance, saturation or contrast, I can edit the adjustment *at any time* without changing the original scan. The procedure below differs slightly from the example in *Workflow 1: Scanning transparencies on the Nikon LS9000*, so you might want to read that workflow description as well.

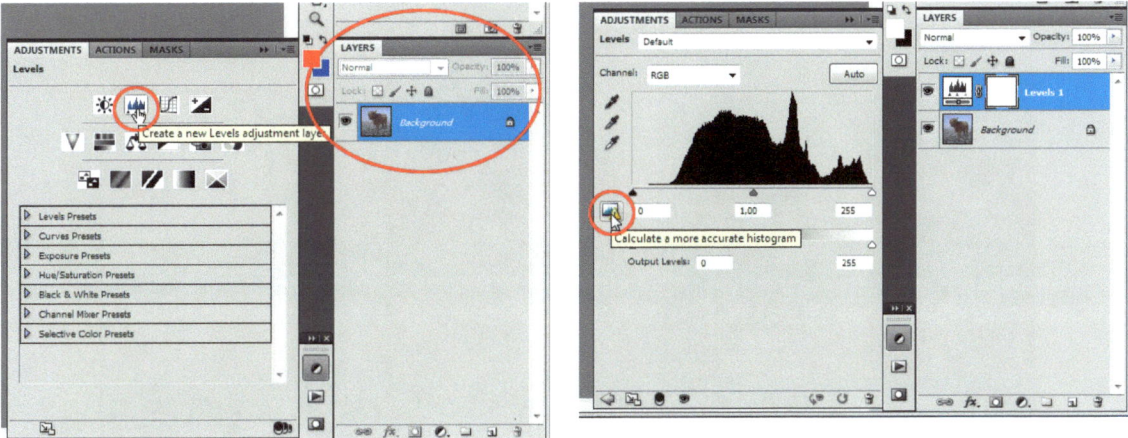

21. There are many options for adapting the Photoshop interface to your personal preferences. I find it convenient to have the **Layers** window in the lower right-hand corner of the screen, with the **Adjustments** palette next to it. Now create a **Levels** adjustment layer, see above. In the **Adjustments** window, click on the warning triangle to calculate an accurate histogram.

I usually start by color balancing the image. I prefer a **Levels** adjustment layer to a **Color Balance** adjustment layer, because **Levels** gives me more control over the separate adjustment of shadow, midtone and highlight color casts.

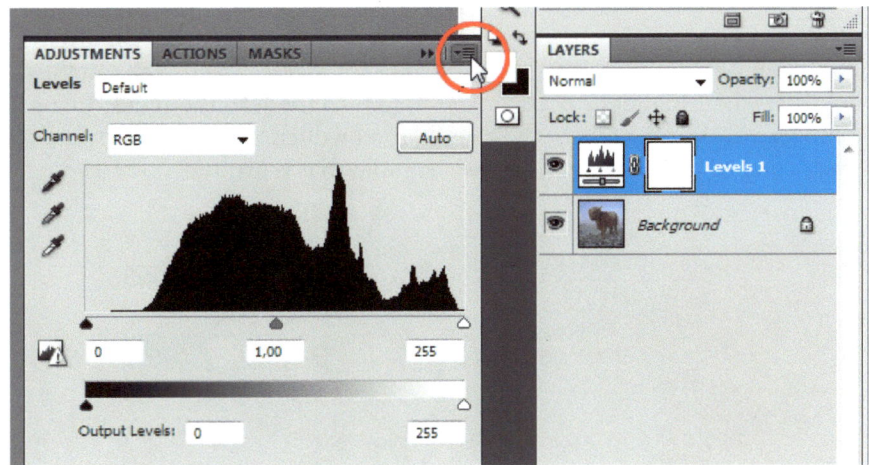

22. Click on the upper right-hand corner of the **Adjustments** window to open the options menu. In that menu, click **Show Clipping for Black/White Points** to activate the option.

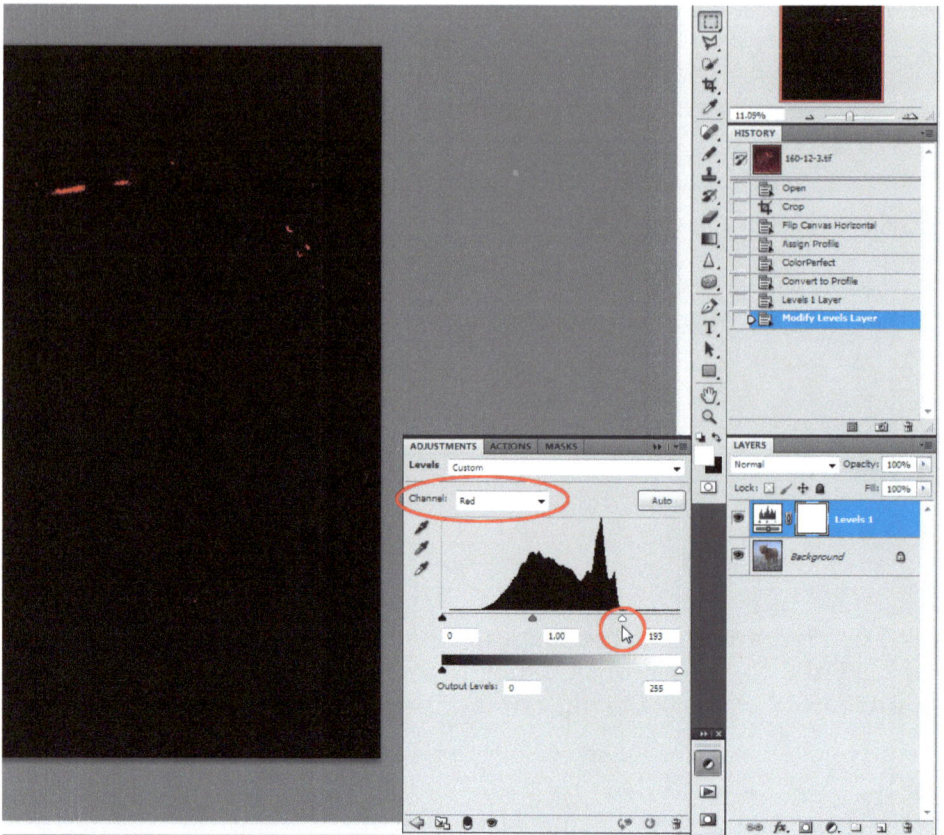

23. In the **Adjustments** window, I activate the **Red** channel in the **Channel** drop-down menu and slide the highlight slider to the left to correct for a green cast in the highlights. While you click and hold the white highlight pointer and drag it to the left, the image turns black. Red blotches start to appear, indicating where the red channel will clip. Drag the pointer to the right again until the red blotches just disappear; in this example that is around value 193.

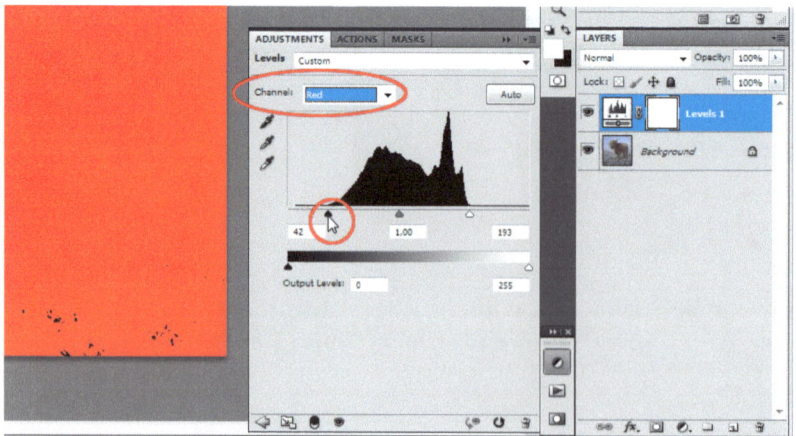

24. Now do the same for the black shadows pointer, to set the black point for the red channel. Drag the pointer to the right; the image turns red. Drag the pointer until the red shadows just start to clip; black blotches appear.

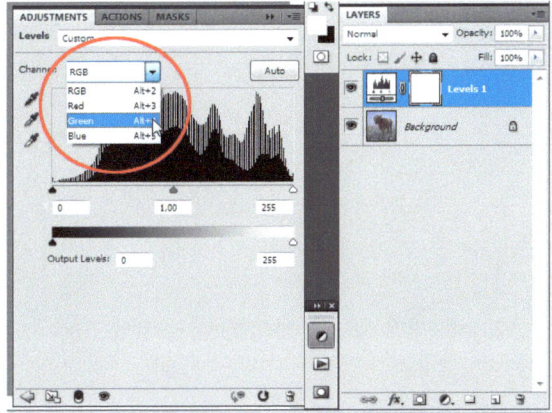

25. Do the same for the **Green** and the **Blue** channels. I find it convenient to switch between channels with the keyboard shortcuts Alt+1, Alt+2 and Alt+3.

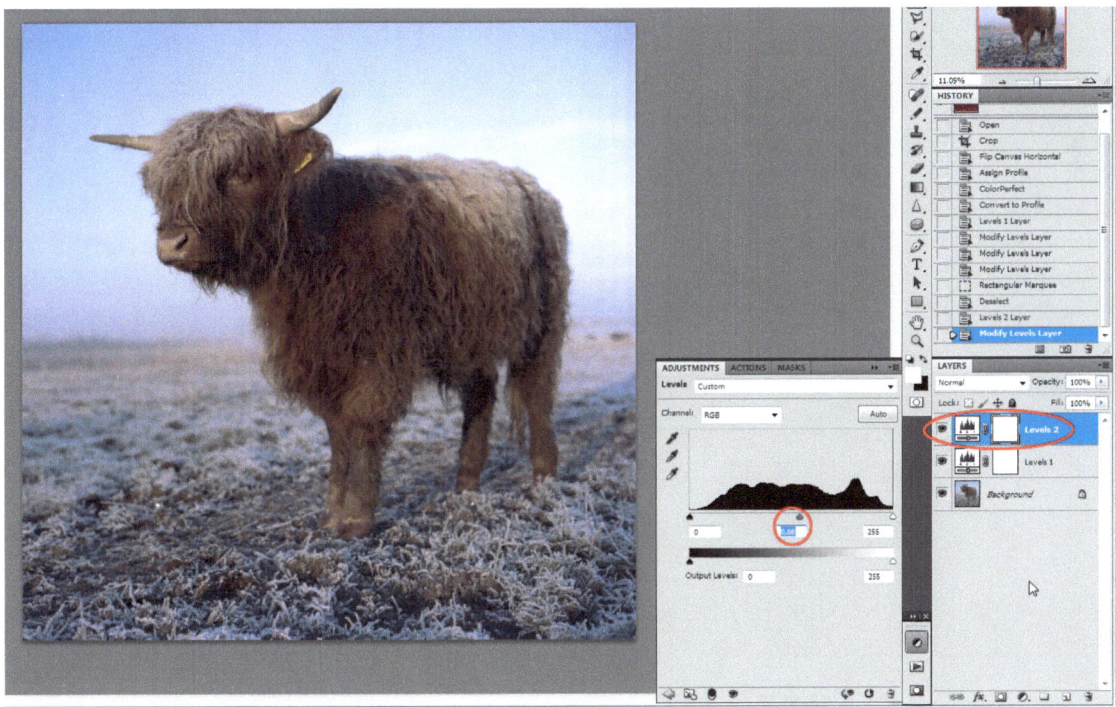

26. When you have finished color balancing all three channels, the image begins to come to life. In this particular example, notice how nicely Kodak Portra 160 has captured those wonderful pastels in the sky. You can fine tune the color balance in the shadows and the highlights by clicking on the values for shadows and highlights in each of the channels and slightly lowering or increasing the values. You have to 'eyeball' those adjustments if the image does not contain pure grays, blacks or whites, as in this example. This of course requires a calibrated monitor.

27. Now I add a second **Levels** adjustment layer. Here I drag the midpoint slider to the right to bring down the brightness slightly. I could do this on the first layer, but I find it gives me more control to correct the color balance in one layer and brightness in another. **Levels** adjustments offer more precise control, so I prefer them to **Brightness/Contrast** adjustment layers.

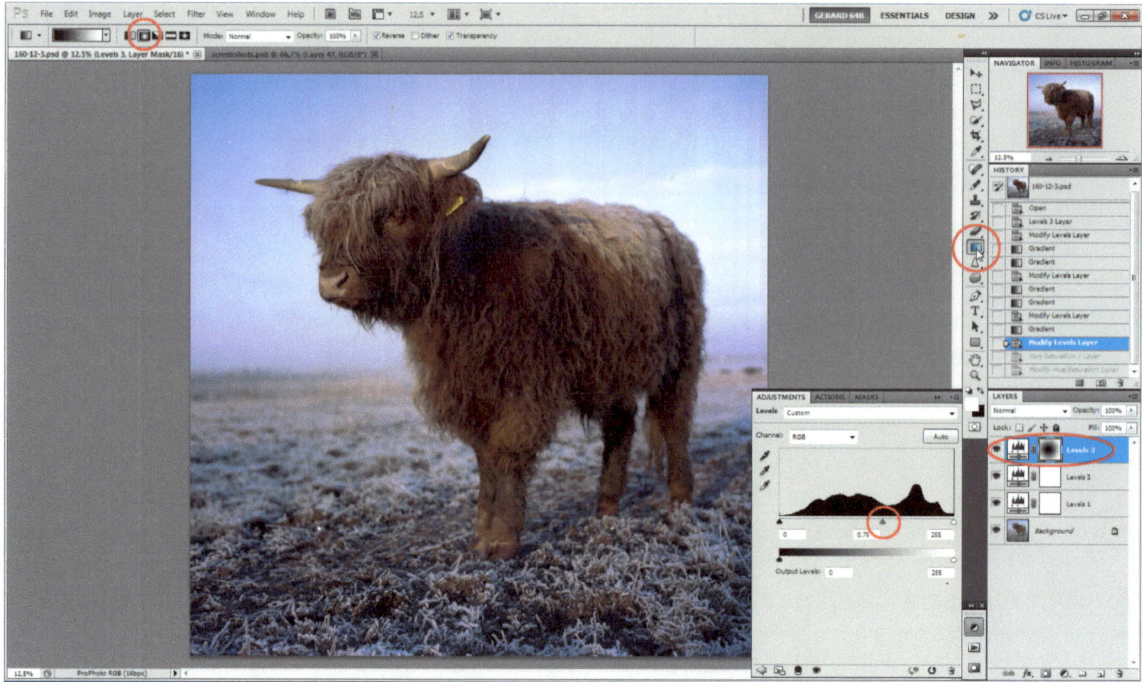

28. In the third **Levels** layer I drag the midtone slider to 0,75 to make the image darker. I draw a circular **Gradient** on the layer mask, which causes the adjustment to apply gradually from 0% in the center to 100% at the edges. The result is a controlled vignette. The image gets slightly darker towards the edges, focusing attention on the cow's head. The midtone value controls the intensity of the effect. You can change this value to suit your taste at any time.

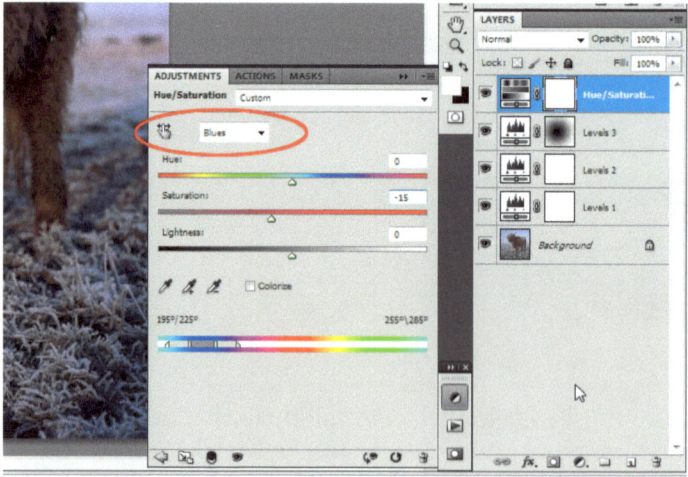

29. Finally, I add a **Hue/Saturation** adjustment layer. Here I desaturate the blues by 15% to balance the harmony between the purples/blues in the sky and the reds/oranges in the animal's coat.

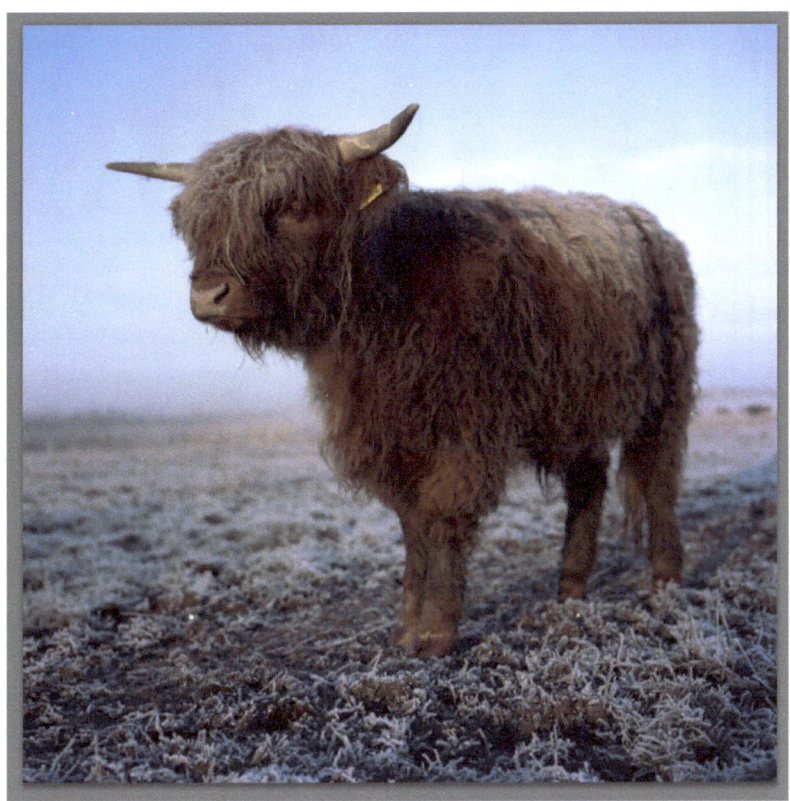

30. Now I save the image as a .psd file, which is the native Photoshop format. All adjustment levels are saved together with the image. I can re-open the file at any time and open any adjustment layer to fine tune any correction that I may have changed my mind about, without affecting the original scan.

About the author

Gerard Kingma is an award-winning photographer from the Netherlands, where he lives in a small village with his wife and two sons. His work has met with critical acclaim, including the 2005 Travel Photographer of the Year – Single Image Award and merit awards from PX3 Prix de la Photographie Paris, Photography Masters Cup, International Loupe Awards, International Color Awards and International Photography Awards.

On assignment, Kingma is always fast and furious with digital equipment, but for his personal work, he likes to slow down and enjoy the craftsmanship of his analogue systems, such as the trusty Hasselblad 501CM or the gorgeous Chamonix 045N-2, a 4x5" large format view camera. He develops his films at home with a Jobo processor. Then comes the tricky part: scanning the films to obtain high-quality digital images, which can be post-processed and perfected in order to make large fine-art prints. His prints are on sale at **www.kingma.nu** and also available at regular exhibitions in the Netherlands.

Into the Frame
by Gerard Kingma

The Illustrated Guide to Film Scanning is accompanied by *Into the Frame*, a portfolio presentation of analogue photographs taken by Gerard Kingma in the past five years. This beautiful 12x12" hardcover edition is printed on luxury paper and contains some fifty richly reproduced images, from both medium and large format analogue cameras. *Into the Frame* is an excellent illustration of what can be achieved with analogue photography, scanned and post-processed using the workflows outlined in this guide. The book is on sale at **www.blurb.com/bookstore**.

For more information on print sales, digital rights-managed usage of images, workshops and exhibitions, please contact Gerard Kingma at **www.kingma.nu**.

www.ingramcontent.com/pod-product-compliance
Lightning Source LLC
Chambersburg PA
CBHW040752200526
45159CB00025B/1869